IS THERE LIFE
BEFORE DEATH?

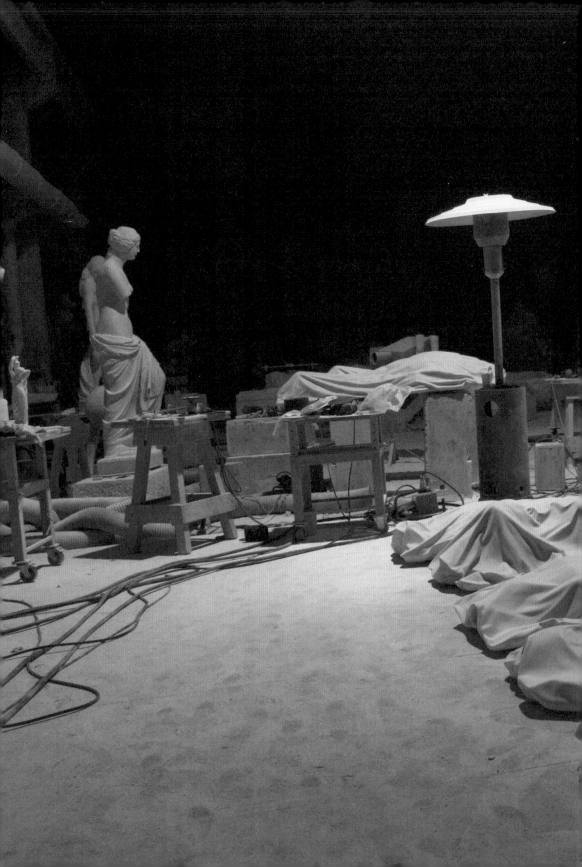

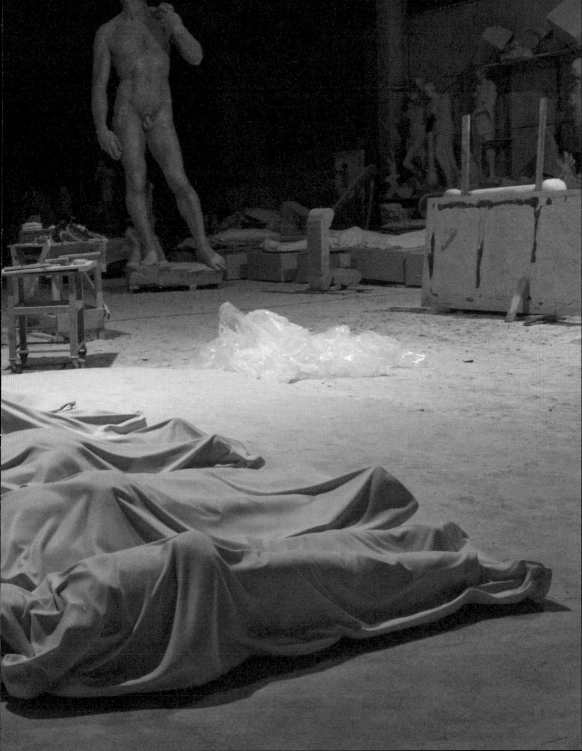

MAURIZIO CATTELAN

IS THERE LIFE BEFORE DEATH?

FRANKLIN SIRMANS

THE MENIL COLLECTION, HOUSTON

DISTRIBUTED BY YALE UNIVERSITY PRESS, NEW HAVEN AND LONDON

LUCIO FONTANA

BORN 1899, ROSARIO, ARGENTINA; DIED 1968

Concetto spaziale, ATTESA (Spatial Concept, WAITING), ca. 1965

WATER-BASED PAINT ON CANVAS

75 X 45 INCHES

It does not matter to us if a gesture, once completed, lives but a moment or a millennium, because we are truly convinced that, once completed, it is eternal.

L.F.

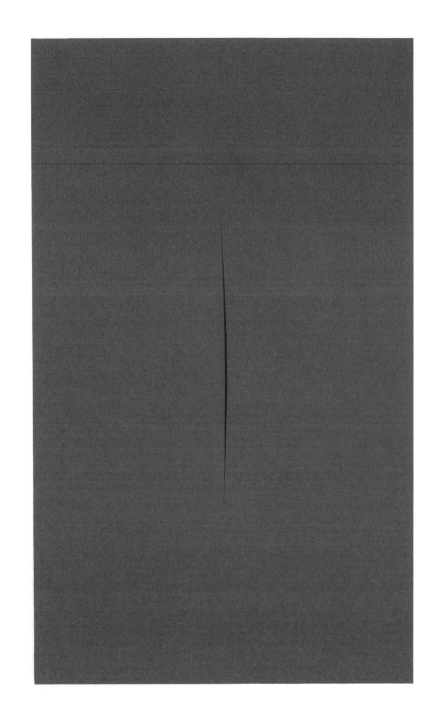

FOLLOWING
M.C.

Untitled, 2009

RUBBER AND STERLING STEEL
19 ⅝ X 7 ⅛ X 15 ¾ INCHES

CONTENTS

ANDY WARHOL
BORN 1928, PITTSBURGH, PENNSYLVANIA; DIED 1987

Double Mona Lisa, 1963

SILKSCREEN INK ON LINEN
28 ⅛ X 37 ⅛ INCHES

FOLLOWING
M.C.

Untitled, 2007

TAXIDERMIED ANIMALS

Kunsthaus Bregenz, 1st floor, Bregenz, Austria

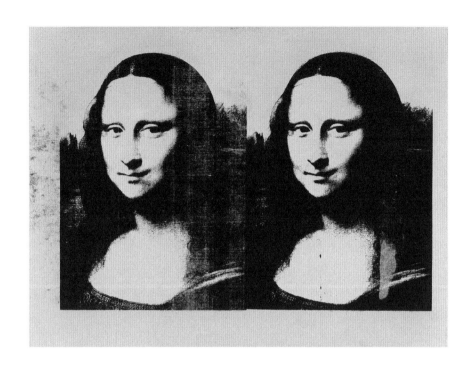

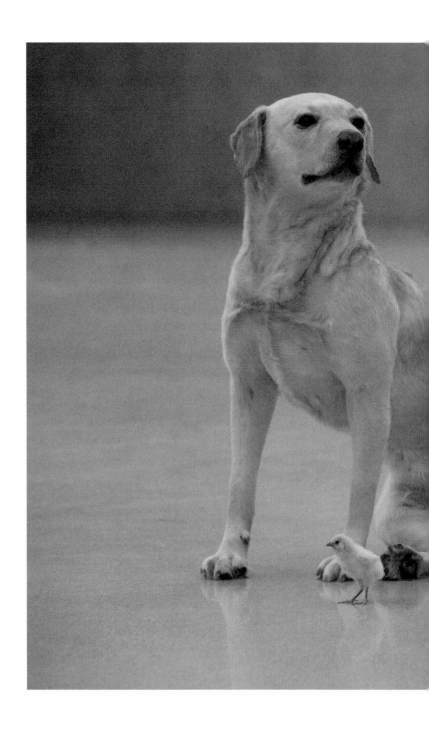

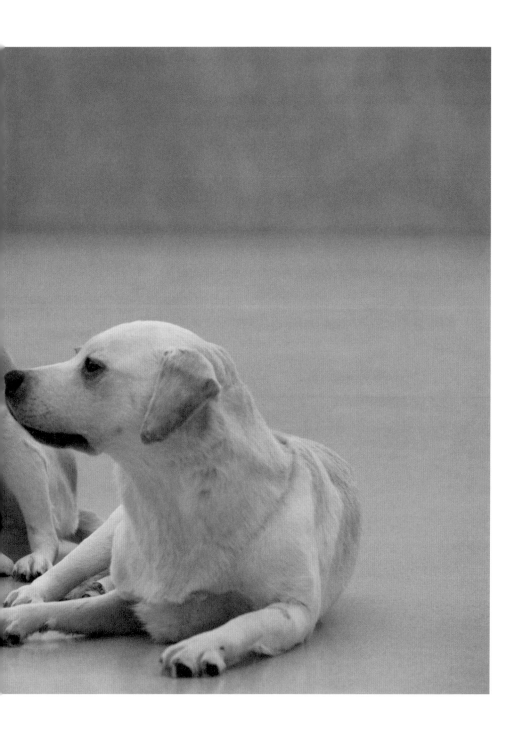

ROBERT RAUSCHENBERG

BORN 1925, PORT ARTHUR, TEXAS; DIED 2008

Glider, 1962

OIL AND SILKSCREEN INK ON CANVAS
96 ⅛ X 60 INCHES

I was busy trying to find ways where the imagery and the material and the meanings of the painting would not be an illustration of my will but more like an unbiased documentation of my observations.

R.R.

FOREWORD

JOSEF HELFENSTEIN

The exhibition at hand and this catalogue, *Is There Life Before Death?*, have grown out of years of interest in the work of Italian artist Maurizio Cattelan, who has been widely recognized as one of the most important artists of his generation. Emerging onto the scene in the mid-1990s, he has been at the forefront of a group of artists celebrated for their nomadic, thoroughly global approach to creating art—while he maintains apartments in Milan and New York, he is constantly traveling. Although his work continues to be informed by international subjects, here at the Menil Collection, his identity as a European artist has special relevance.

The founders of the museum, John and Dominique de Menil, celebrated their dual identities as Europeans and Americans through cultural exchanges across the Atlantic. Prior to the opening of the Menil Collection, the de Menils were instrumental in introducing American artists to Europeans and European artists to Americans. John de Menil began his twenty-year service to the Museum of Modern Art, New York, in 1954, when he became a member of the museum's International Council, which to this day sends exhibitions to Europe and other parts of the world. In 1974, Dominique de Menil joined the Acquisitions Committee of the Centre Georges Pompidou, Musée national d'art moderne, Paris, one of only two private collectors recruited to the committee. In 1975–76, aiming to introduce American contemporary artists to France's national collection, she gave works by Claes Oldenburg, Larry Rivers, and Andy Warhol to the museum in memory of her husband. Later, in this country, she championed French artist Yves Klein when he was still little known in the United States, organizing a retrospective of his work, which toured nationally in 1982.

In addition to his European roots, Cattelan's work resonates with much of the art the de Menils collected. Like the Dadaists and Surrealists, whose works constitute a major area of concentration at the museum, Cattelan, with his emphasis on the uncanny, uproots traditional notions of art and understanding. In combining the language of popular culture with Conceptualism, his work tackles big issues with a graphic sensibility that recalls not only Marcel Duchamp, but also postwar artists Jasper Johns and Andy Warhol. Such connections will be explored in this exhibition. Working closely with the artist, curator Franklin

Sirmans will juxtapose Cattelan's works with selections from the museum's collection. With a focus on placement and presentation, Sirmans will create dialogues among works in the galleries by positioning Cattelan's art in potentially stark contrast to their surroundings, not only alongside modernist pieces, but also near objects within the antiquities and Oceanic galleries.

Artist participation is a tradition at the Menil. In 1969, John de Menil worked with Warhol on "Raid the Icebox I with Andy Warhol," which was an exhibition the artist culled from the art storage of the Museum of Art at the Rhode Island School of Design. Periodically the Menil has revisited this model in temporary exhibitions with artists Anna Gaskell, Robert Gober, Otabenga Jones, Luisa Lambri, David McGee, Vik Muniz, and now Cattelan. We invited Cattelan to create an exhibition of his work within the context of the Menil Collection's unique holdings as well as the aesthetics of their presentation. For Cattelan, this style of working is nothing new.

The ambivalent emotions that his sculptures often elicit set him apart from his peers, as does his practice of working in a slow, methodical way. After a quiet period in his sculpture making—he worked on other projects, including curating the Berlin Biennial in 2006—Cattelan has returned to a more object-oriented practice. His recent exhibitions have emphasized the idea of insinuating his works quietly into the context at hand; they have included shows in Frankfurt and London, one in the permanent collections of the Museum für Moderne Kunst and the other at Tate Modern. Here at the Menil, a selection of new works made for this exhibition will be joined by several large-scale sculptures, including the monumental, somber *All*, 2007. Considering Cattelan's works in the context of the Menil's holdings—with a focus on works of modern and contemporary art—enables us to see what "conversations" emerge and also affords us the opportunity to appreciate Cattelan's works against the backdrop of twentieth-century art.

EDWARD RUSCHA
BORN 1937, OMAHA, NEBRASKA

Hurting the Word Radio I, 1964

OIL ON CANVAS
59 ⅛ X 55 ⅛ INCHES

As I see it, 'Pop' comes from the word "popular" and manufactured popular culture is what always inspired me early on. Something printed on paper or a plastic sign was always more vital than involving myself in a landscape. California is no more pop than Oklahoma, Florida or New York, although a little more than, say, Alaska or some desert isle.

E.R.

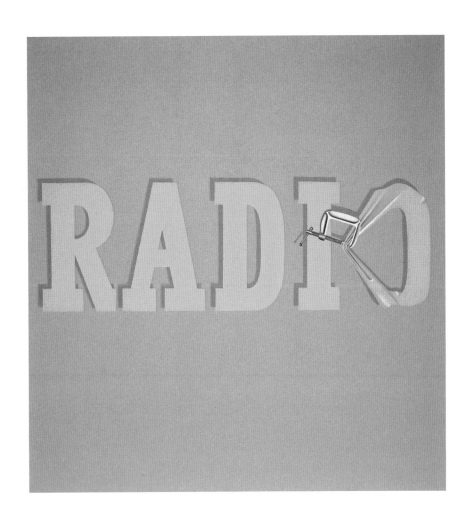

FOLLOWING
M.C.

Untitled, 1996

BLACK-AND-WHITE PHOTOGRAPH
19 ⅝ X 23 ⅝ INCHES

MAURIZIO CATTELAN: IMAGE MAKER

FRANKLIN SIRMANS

Today we mostly see art through photos and reproductions. So in the end it almost doesn't matter where the actual piece is. Sooner or later it's gonna end up in your head, and that's when things get interesting. I'm more interested in brains and memories than in site-specific works.[1]

—MAURIZIO CATTELAN

In the past twenty years, Maurizio Cattelan has created an oeuvre that includes sculpture, installation, publications, and artistic actions. At the heart of his endeavors has been the desire to create a body of images that, one could say, "lives in your head,"[2] in the subconscious—mental images that he realizes are triggered not so much by seeing his work in the flesh as through seeing reproductions of it in print and online. The creation of images, as opposed to physically tangible lasting objects, drives his artistic production: "It feels strange to talk about sculptures. It's not so much a question of means as of images. I never even use my hands to create my work, just my ear glued to the phone. More than anything else, I listen to the murmur of images."[3] In fact, Cattelan often destroys works after they have been exhibited once or a few times, leaving photographs of the pieces as the lasting images. "Some pieces are made only for site-specific situations. . . . Some works are not strong enough to remain as sculptures," he says.[4] Cattelan often first visualizes his works in two dimensions—how it will look on the printed or digital page—perhaps because of the sometimes daunting figurative and literal weight of making sculpture. "I always start with an image, never with a meaning."[5] Yet meaning is what Cattelan's work drives home time and again. While the artist stresses that the image is the transporter of ideas, one that spreads readily around the world in multiple formats, from the Internet to magazines and newspapers to television screens, he is equally concerned with the three-dimensional object. Cattelan knows it has to be good in order to create a great image. Otherwise, he will remove it from circulation and therefore cut short its life as a reproduction. "I see that art has a great potential to refer to a broader debate, to go out there and reach an incredible audience. And if my work can't do that, well, it's useless."[6]

I first met Cattelan in 1996 when I was working in Milan at *Flash Art* magazine. We got together at a café to look at and talk about one of his longest-running projects, *Permanent Food*, 1996–2007, which he created with artist Dominique Gonzalez-Foerster, who left the project after the second issue. Built entirely from images taken from various sources, *Permanent Food* was

a second-generation magazine containing no text, just pages of illustrations contributed by artists and other friends who were invited to participate. Carefully edited by Cattelan and Paola Manfrin, art director of the ad agency McCann Erickson in Milan, the illustrations sometimes produced narratives, but more often than not, the magazine simply aimed to present images that looked good together and would leave the greatest and most enduring impression once the book had left one's hands.

Although *Permanent Food* focused on imagery alone, Cattelan also devotes time to writing: since 2007, he has been a contributor to *Flash Art*, primarily interviewing other artists. In the last several years, he has also been involved in curatorial-related projects, including the creation of the Wrong Gallery with curators Massimiliano Gioni and Ali Subotnick in 2002. An alternative art space comprising a doorway with an enclosure roughly two feet deep, the Wrong Gallery has been the venue for more than forty wide-ranging exhibitions. Originally located on 20th Street in Manhattan's Chelsea district, it is still in business, having relocated most recently to the Tate Modern in London. In spring 2005 Cattelan set up shop in Berlin for a year, co-curating the 2006 Berlin Biennial with Gioni and Subotnick.

Within the last few years, the artist has returned to making sculpture, and we are pleased to be showing several of his recent works at the Menil Collection. While the exhibition can be considered Cattelan's first solo museum show in the United States since 2003, and it includes the debut of three new sculptures, it is also a group show, featuring a range of objects—mostly from the 1960s and 1970s—from the Menil's holdings. Cattelan was integrally involved in selecting the works for the exhibition, and his trademark biting wit is ever present. He has emerged as one of the most important artists of the current generation, perhaps because he infuses his work not only with humor but also with intelligence. By fluidly combining the accessibility of Pop Art and the unpredictability of Dada and Surrealism with iconic and

ALIGHIERO E BOETTI
BORN 1940, TURIN, ITALY; DIED 1994

Calligrafia, 1971

BRASS
15 ¾ X 15 ¾ INCHES

Borsa. Valori.
Centro Meccanografico
14 v. s.u. al Teatro
Milano tel. 877038

Boetti Alighiero
64 v. Del Carretto
Torino tel. 877038

Lido Airone (srl) Frine
v. Domitiana Km. 41,838 Castelvolturno
Lago Patria
Napoli. tel. 877038

Calenda. Dr. Carlo
15 v. D. Cirillo
Roma. tel. 877038

P.C.I.
Sezione Firpo A. 1/canc; p. Romagnosi
tel. 877038
Genova.

Fabiani Fratelli. Sfilacciatura Garnettatura
v. Carmignanese. Poggio A. Caiano
tel. 877038
Firenze. Torino 21 aprile 1971

often controversial imagery (the Pope, headless horses, and the Nazi salute) Cattelan's work "lightens" the disturbing aspects with absurdity; nevertheless, they linger in the mind to be sorted out later. The way he has approached installation and has insinuated himself into spaces and among the works of others (and into the culture at large) is subtle and clever, evidence of a sly and cunning mind.

For this show, Cattelan and I chose from the museum's extensive collection of works by Andy Warhol, an artist who has exerted a particular influence on him, along with works by others he admires: Robert Rauschenberg, Jasper Johns, Cy Twombly, Bruce Nauman, Ed Ruscha, Joseph Kosuth, James Lee Byars, and Robert Morris. Because Cattelan's lineage harks back to the Arte Povera movement in Italy (though how those artists influenced him is debatable), we have included several pieces by Michelangelo Pistoletto, Alighiero e Boetti, and Giovanni Anselmo, and their forerunner, Lucio Fontana. (We have been able to augment this specific group of works thanks to Houstonians Nina and Michael Zilkha, who lent several pieces.)

As much as it makes sense for Cattelan's work to be contextualized among modern and contemporary artists, this project also takes place at an opportune time for the Menil Collection. As the first decade of the twenty-first century begins to recede from view, a crucial aspect of the museum's curatorial endeavors comes to light through this exhibition. How will the curatorial staff position contemporary art at the Menil in the future? Historically, getting insight from living artists about the museum and its collection has been an essential part of the equation. Since the Menil is primarily made up of four major and vastly different divisions—antiquities; Byzantine art; African and Oceanic objects; and modern and contemporary art—Menil curators have been faced with the challenge of finding ways in which contemporary artists can find resonance with this eclectic group of objects. In addition to creating permanent single-artist exhibition spaces for postwar artists Dan Flavin and Cy

Twombly (the latter's work appears with Cattelan's), the Menil has organized short-term "intervention-like" shows as well. At different times since 2002, artists Vik Muniz, Anna Gaskell, Luisa Lambri, David McGee, Robert Gober, and Otabenga Jones have delved into the collection in order to invigorate the ongoing discussion about "the Menil in the moment." It is within this spirit that we have partnered with Maurizio Cattelan.

These collaborations with artists, begun in the first ten years of the twenty-first century, continue the legacy established by the museum's founders, John and Dominique de Menil. Long before the museum was built, the de Menils had worked closely with contemporary artists, seeking their views on the growing collection. Two who were particularly influential were Max Ernst, whom they met in the 1930s, and Andy Warhol, whom they met in the 1960s. While Ernst became a close friend and adviser, with Warhol the de Menils embarked on a curatorial collaboration of sorts. In 1969, while on a tour of the Rhode Island School of Design (RISD) Museum of Art's storage rooms, John de Menil, impressed by the rich and vast collection, proposed to the director, Daniel Robbins, that an artist mine the rooms and create an exhibition from his discoveries. He suggested Warhol, who then curated "Raid the Icebox I with Andy Warhol," which was shown at RISD and then at the Rice Museum at Rice University in Houston, an institution run by the de Menils. Coming full circle, Warhol's work has now been mined by Cattelan for this exhibition.

Yet another apropos reason for a partnership between Cattelan and the Menil is their mutual binary foundation in America and Europe. While modern and contemporary art—in the Western tradition in the twentieth century—are often said to have had a pre–World War II base in Europe (Paris) and a postwar base in America (New York), what is interesting is the futility of this structure of thought in the twenty-first century, when not only images traffic in a universal language, but so do international artists. Thus Cattelan is well suited for this project because, as clichéd as it may sound, he is a global artist.

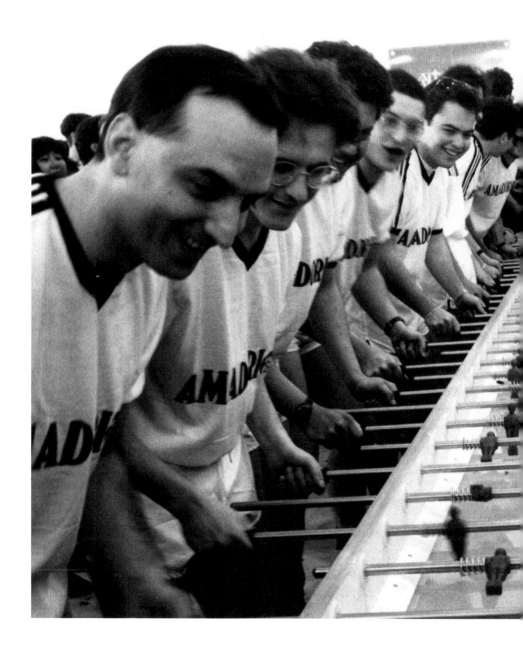

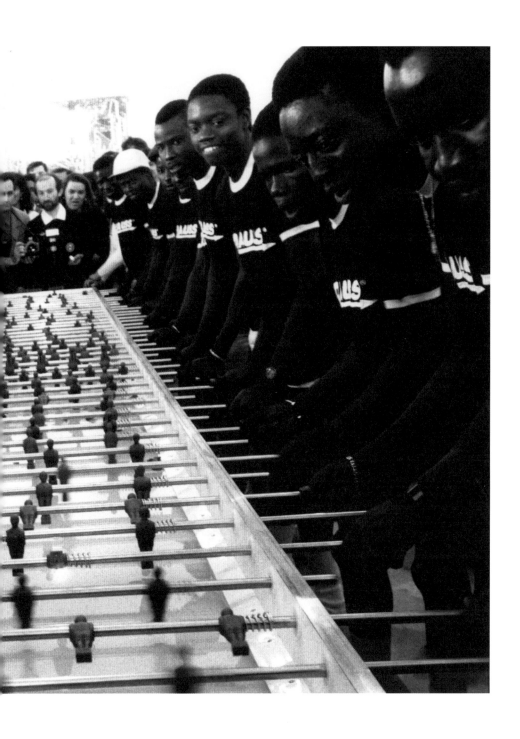

He lives in New York but maintains a flat in Milan, where he began his career. Alghough he is deeply involved in the country of his birth (he was born in Padua, Italy, in 1960) and its history (especially with regard to art and politics), he also functions in the world of global art and images.

While he does much of his work in New York, Cattelan still represents Europe, more specifically Italy, and even more specifically northern Italy. As the curator and writer Francesco Bonami observed, Cattelan is *il ragazzo di Padova* (the little boy of Padua).[7] In works such as *Stadium*, 1991, *Lullaby*, 1994, and *Il bel paese (The Beautiful Country)*, 1994, Cattelan has invoked controversial Italian history. In *Stadium* he brought to the fore Italy's xenophobia in the face of increased immigration by organizing a soccer team with men from Senegal under the name AC Fornitore Sud (Southern Suppliers Football Club). Wearing jerseys with *RAUSS* imprinted on them, (referring to the German word *raus*, which means "get out!"), the team actually participated in a local league in Bologna, playing in an exhibition game with a major league team. A related piece, *AC Fornitore Sud (Southern Suppliers FC)*, 1991 (PP. 32–33), involved the team's playing an absurd game of foosball with eleven players per side at the table. Inspired by a different, though equally politicized recent event, *Lullaby* is composed of sacks of rubble from the 1993 terrorist bombing of the Contemporary Art Pavilion in Milan; the work was shown at the Laure Genillard Gallery in London in 1994. This was the first in a string of bombings alleged to have been carried out by the Mafia as a declaration of its power against the state. The Uffizi in Florence and a church in Rome were bombed soon after. Not just art and architecture, but the heart and soul of Italian culture were being attacked. In a more benign version of Italy's undermining, Cattelan created *Il bel paese*, a rug featuring the logo of a popular brand of Italian cheese that includes a map of Italy. It was placed on the gallery floor in the exhibition "Soggetto, Soggetto" ("Subject, Subject"), 1994, a show celebrating new Italian art at the Castello di Rivoli, where it was overlooked—literally stepped on and worn out—by visitors to the exhibition.

Though rooted in specific experiences and specific locales, these works speak to universal issues of intolerance, violence, and ignorance. As the artist himself has said, "Those who work following their instinct, responding to a determinate situation in a personal way, can end up having collective results and affect the world."[8] John and Dominique de Menil likewise believed in the power of art to communicate beyond geographic boundaries. As global citizens themselves, having traveled extensively worldwide and with residences in Paris, New York, and Houston, they were advocates of artists, such as Max Ernst, René Magritte, and Yves Klein, who had propelled European art from the School of Paris to a more global stage. The de Menils expanded their interests with so-called American "Neo-Dadaists," like Johns and Rauschenberg, and with Warhol, whose work speaks a particularly American visual language heard around the world.[9] In light of this dual identity that defines the Menil Collection, Cattelan's presence at the museum provides a nuanced vision that spans the Atlantic, helping us to understand the global present and test the geographical boundaries that we might place on art in the future.

Looking to consider the works as they relate to their environs, I decided to approach working with Cattelan on this installation with an open mind and a subtle touch, much in the same way he normally works. Uninterested in filling a room with his art—the standard, crowd-pleasing, and *tempting* presentation of a popular contemporary artist—we will place his very recent pieces throughout the museum, some quietly inserted into the nooks and crannies of the building, and others more prominently placed, such as *Untitled*, 2003 (P. 37), which will be on the roof, and the monumental sculpture *All*, 2007 (PP. 102–03), which, due in part to its sheer size, will be in one of the largest galleries. As this text is being written prior to the completion of the final installation plans, the following pages provide a general rumination on Cattelan and his oeuvre, works in the Menil Collection, and how they relate to each other. A torrent of images follows, naturally.

PREVIOUS

M.C.

AC Fornitore Sud (Southern Suppliers FC), 1991

Game played at "Anni 90" exhibition, Galleria d'Arte Moderna, Bologna

M.C.

Untitled, 2003

RESIN BODY, SYNTHETIC HAIR, CLOTHES, ELECTRONIC DEVICE, AND BRONZE DRUM

31 ½ X 33 ½ X 22 INCHES

Rachofsky House, Dallas

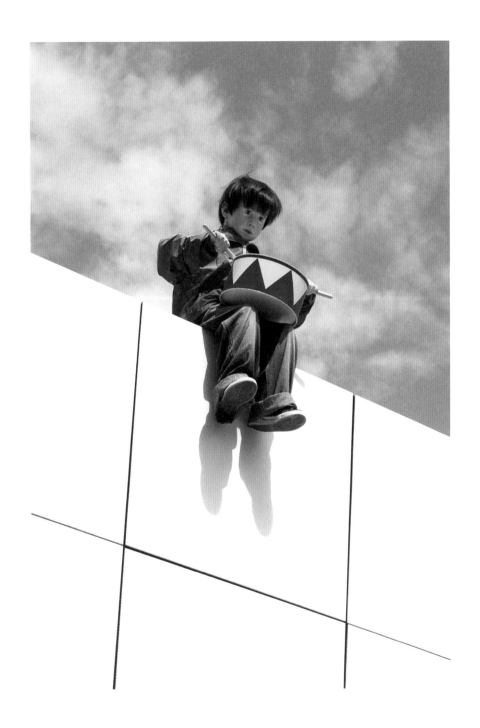

Nine bodies lie shrouded, apparently draped in cloth with many soft folds, perhaps suggestive of the supple nature of skin, but all are rendered in marble. Are they bodies in a morgue, laid out after some natural disaster, victims of terrorist violence, or just regular folk whose time has come? Some of the deceased in Cattelan's *All* are curled not quite in a fetal position, but comfortably, suggesting a quiet demise. They are anonymous: no distinguishing features or uniqueness sets them apart. How often is death rendered figuratively in contemporary sculpture? Historically, sculptures memorializing the departed were usually created as life-size or greater than life-size portraits, capturing the person's vitality. In contemporary works, the physical presence of the dead is often captured abstractly, such as in Maya Lin's *Vietnam Veterans Memorial*, 1982, or Doris Salcedo's *Atrabiliarios*, 1992–93. An exception that comes to mind is Eric Fischl's *Tumbling Woman*, 2001, a sculpture he made soon after the World Trade Center towers collapsed. Appearing to be falling, the bronze figure was exhibited on the ground floor of Rockefeller Center in Manhattan in September 2002. However, it was removed a month later due to angry protests: the period of mourning was still nascent, and many were not ready for an image so brutal. While *Tumbling Woman* commemorates a specific event of great magnitude with a single body, *All*, vague in its repetition of anonymous figures, is powerful due to its ambiguity. It could represent the mass of faceless victims who are executed every day in relative obscurity, away from the media's cameras. Or it could represent those affected by naturally occurring tragedies, such as the 2004 tsunami in the Indian Ocean or Hurricane Katrina in New Orleans in 2005. Or it could represent the end for you, me, or the artist. The marble signifies the permanence of death, and the anonymity and the repetition of the figures, combined with the title, denote its inevitability.

Since *All* could be viewed as a recent tour de force, we considered it in the context of several seminal works in the Menil Collection dating from the late 1960s to the early 1970s that helped to put Conceptual Art on the map. Notions such as anti-commodification, social and/or political critique, and ideas and information as media—characteristic themes in Conceptual Art that continue to be important topics today—are captured in works by Joseph Kosuth, Ed Ruscha, Robert Rauschenberg, Robert Morris, and Bruce Nauman.

Joseph Kosuth's circa 1967 work *Titled (Art as Idea as Idea) [meaning]* (P. 89) is an icon of early Conceptualism. In this work, as in many others by Kosuth, the artist has employed language as his medium. A photostat of a dictionary definition is presented on a square panel measuring about four-by-four feet. Although displayed as a conventional painting (sans pictorial content, color, and line), the piece is meant to question the concept of what an artwork is; in this case, Kosuth has indicated that it is an idea, presented here as words. Whereas Kosuth's work evokes the absence of what we recognize as typical artistic material, by working with language in a "pure" form, Ed Ruscha's *Hurting the Word Radio I*, 1964 (P. 21), creates the illusion that the word itself that he painted has material properties beyond the oil paint with which it was made. In Ruscha's painting of a word distorted by a common C-clamp, Kosuth's notion of language as immaterial idea meets its bold Pop contemporary; the image of language pulled and stretched like a synthetic textile evokes another, more commonplace alternative to what we recognize as artistic material.

In *Glacier (Hoarfrost)*, 1974 (P. 93), Robert Rauschenberg replaced traditional canvas with billowy satin and chiffon, taking materiality in another direction. The artist silkscreened images of popular culture from his archive directly onto the surface of the amorphous fabric, recalling the Neo-Dada tendencies in his work that surfaced in the 1950s and which ushered in the

ROBERT MORRIS
BORN 1931, KANSAS CITY, MISSOURI

Untitled, 1968

TWO PIECES OF CUT FELT
DIMENSIONS VARY

Recently, materials other than rigid industrial ones have begun to show up.... Sometimes a direct manipulation of a given material without the use of any tool is made. In these cases considerations of gravity become as important as those of space.
R.M.

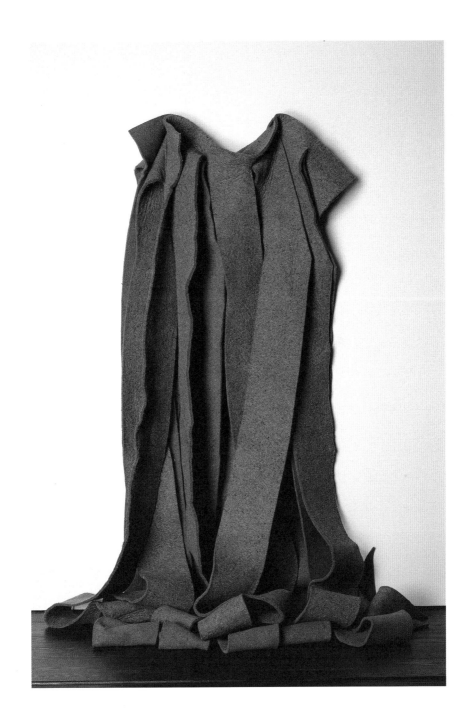

rapid changes from formal and traditional artistic strategies to the "whatever-works" methods that he helped to bring about in postwar contemporary art. Championed for the "combine" paintings he made between 1958 and 1962, Rauschenberg consciously sought to close the gap between art and life by incorporating found materials in his works. In the later *Glacier (Hoarfrost)*, the effect is more minimal: the appropriated images are subservient to the materials.

Like Rauschenberg, artist Robert Morris embraced material presence with a series of works made of industrial felt. In much the same way that the gentle folds of *All* are made of hard marble—recalling a time, such as in Roman classical art, when that material was commonly used by sculptors—Morris's soft felt sculpture *Untitled*, 1968 (P. 41), places strong emphasis on the material qualities of felt with no concern for thematic subject matter. Felt, a stiff, unruly, and at the same time heavy and flaccid fabric, is the "anti-form" in this piece. Its large, gray, draping presence offers an interesting comparison to Cattelan's *All*. Like Bruce Nauman's early sculptures *Untitled*, 1965 (P. 77), and *Untitled*, 1965–66 (P. 113), fashioned from common industrial materials (latex, fiberglass, resin, and neon tubing), Morris's abstractions deliberately focus on chance: due to the yielding nature of the material, the works are altered with every presentation; a dance forms between his sculptures and the viewer with each new configuration. This seemingly chance dance was something the artist explored in his 1968 essay "Anti Form": "Random piling, loose stacking, hanging, give passing form to the material. Chance is accepted and indeterminacy is implied since replacing will result in another configuration."[10]

Morris's felt piece may also recall the work of Joseph Beuys, an artist Cattelan has referenced in his own work. Known for using felt as a medium in several of his pieces, Beuys, a German artist and activist working after World War II, has been a central force in the discussion of how art and celebrity can

advance political views, something Cattelan has achieved in his personal life and addresses through his work. (Let us not forget Cattelan's donning enormous masks of art icons Georgia O'Keeffe and Pablo Picasso in *Georgia on My Mind*, 1997, and *Untitled*, 1998, respectively.) Well-known for the profile he cut in trademark boots, vest, and felt hat, Beuys also was known for his felt suit. In 2000 Cattelan created a small sculpture of himself dressed in a Beuysian suit and hoisted onto the hook of a clothing rack as if hung out to dry (P. 45). Although the title of Cattelan's piece comes from Beuys's work *La Rivoluzione Siamo Noi (We Are the Revolution)*, 1972, Cattelan's work also references the equally iconic *Filzanzug (Felt Suit)*, 1970. Is Cattelan questioning the power of art and/or the artist to effect change? Beuys called for a revolution in the desperate and tumultuous times of the early to mid-twentieth century; Cattelan prods people in the prosperous and lackadaisical times of a half-century later. The artist considers this piece a "tribute" to his German forebear, and in light of the seriousness of Beuys's call to civil action, Cattelan's humor is sobering.

M.C.

La Rivoluzione Siamo Noi (We Are the Revolution), 2000

POLYESTER RESIN FIGURE, FELT SUIT, AND METAL COAT RACK

PUPPET: 49¼ X 12½ X 20½ INCHES

WARDROBE RACK: 72¾ X 18½ X 20½ INCHES

Migros Museum für Gegenwartskunst, Zürich

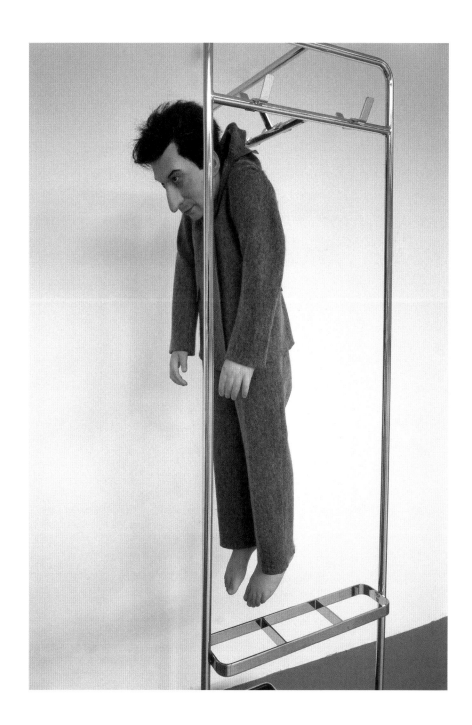

Playing fast and loose with icons of art history—usually with a sense of lighthearted humor—Cattelan has become known for donning masks not only physically, but metaphorically. His type of humor is steeped in an Italian tradition dating back to the Renaissance and the acting troupes of the commedia dell'arte. Like the playwright Dario Fo and the actor Roberto Benigni, he has accepted the mantle of an accomplished and important Italian artist, knowing that his national identity is integral to his status in the broader international picture of contemporary art. In his writings, curator Francesco Bonami has expounded on and elucidated Cattelan's work in the context of modern Italian art history, particularly in the exhibition catalogue for "Fatto in Italia," 1997; in the book *Maurizio Cattelan*, 2000; and most recently in the 2008–09 exhibition "Italics: Italian Art Between Tradition and Revolution, 1968–2008" at the Palazzo Grassi in Venice.

Cattelan was launched onto the international stage with his inclusion in the Italian Pavilion of the 47th Venice Biennale in 1997 when, in his survey of Italian art in the twentieth century, curator Germano Celant established Cattelan's significance as an Italian artist, and an heir to Arte Povera in particular. Celant coined the name Arte Povera in 1967, referring to a group of postwar artists who shunned traditional artistic practices and emphasized process instead by using unconventional or "poor" materials, such as felt, rubber, and neon tubing. Taking a stab at Arte Povera as its renegade heir, Cattelan used materials "on-site" in *Turisti*, 1997, his piece for Celant's exhibition at the Biennale, with the not-so-insignificant difference of fabricating high-end replicas of existing materials. As he explained, "The 1997 Biennale was, for me, very exciting. And I think Germano Celant's idea of mixing generations was the best solution to the Italian problem. . . . I had gone to see the pavilion in Venice about a month before the opening of the exhibition. The inside was a shambles and it was filled, really filled, with pigeons.

For me as an Italian, it was like seeing something you're not supposed to see, like the dressing room of the Pope. But then again, that is the situation in Venice, so I thought I should just present it as it is, a normal situation. And of course, where there are pigeons, there is pigeon shit."[11]

Cattelan's relationship to Arte Povera is fraught with ambiguities, as are most generational gaps in art history. That Cattelan finds sustenance, or at least creative juice, in both admiring and questioning the movement, to some degree, echoes Rauschenberg's skeptical stance on Abstract Expressionism. (In a gesture similar to Cattelan's untitled series of paintings that both mock and pay homage to Lucio Fontana, Rauschenberg famously erased an actual Willem de Kooning drawing given to him by the artist in 1953.) But for Cattelan, a highly conceptual artist, the work of Arte Povera artists has a special resonance, as it does for us, too, as viewers, writers, and critics. It was an exhibition of work in Padua by Pistoletto that sparked Cattelan's interest in art and in the possibility of making art for a living. In a new work being created for this exhibition, Cattelan invokes the work of another Arte Povera artist, Alighiero e Boetti, and his concepts of autobiographical duality as explored in the autoportrait *Gemelli (Twins)*, 1968. However, unlike the Arte Povera artists, Cattelan is less interested in the process of making art than in the final forms: object and image. His work is fabricated, while the Arte Povera artists, keen to disrupt the commercial structure of contemporary art's consumption, embrace ephemeral materials. Not exactly a finish fetishist, Cattelan creates works that nevertheless evoke high production, reflecting the glossy world in which we live. We are even comfortable with the materials he uses—wax body parts and taxidermied animals—due to our familiarity with wax museums, film, television, and the material sensibilities of Cattelan's peers, such as Ron Mueck, Takashi Murakami, and Damien Hirst.

CY TWOMBLY

BORN 1928, LEXINGTON, VIRGINIA

Untitled, 1969

OIL-BASED HOUSE PAINT AND WAX CRAYON ON CANVAS

79 ⅛ X 102 ⅞ INCHES

I'm southern and Italy is southern. Actually, it wasn't all that scholarly, my reason for going to Rome. I liked the life. That came first. And the background of architecture, which is one of my many passions, a great background.

C.T.

LUCIO FONTANA

Concetto spaziale, Attese (Spatial Concept, Waiting), 1959

SYNTHETIC PAINT ON CANVAS

39 ¾ X 49 ¼ INCHES

FOLLOWING

M.C.

Untitled, 2009

CANVAS, WOOD, AND PLASTIC

82 ⅝ X 33 ½ X 23 ⅝ INCHES

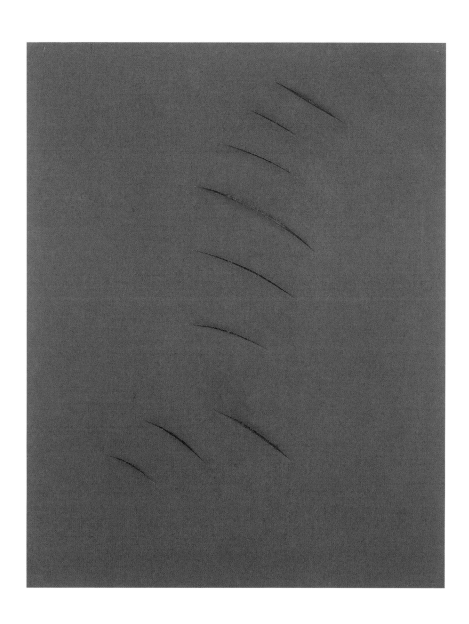

While Marcel Duchamp and his concept of the readymade hover in the metaphorical and literal background of the exhibition (works in the Menil Collection include Duchamp's *L.H.O.O.Q.*, 1919, and *Wedge of Chastity*, 1954), a direct precursor to the Arte Povera artists, Lucio Fontana, is represented more prominently by three paintings. Fontana, who founded Spatialism, the mid-twentieth-century Italian movement to integrate art with science and technology, made an important body of works called *Concetto spaziale (Spatial Concept)*, beginning in 1949 (PP. 7, 51, AND 105). Puncturing thinly painted monochromatic canvases with a knife, Fontana "cut out" the traditional space of art. This simple act of destruction challenged centuries of Western art, shifting the focus of easel painting from pictorial illusionism to the material properties of the canvas itself.[12] Cattelan acknowledged Fontana in his wry untitled paintings of 1996–98 in which he made cuts into the centers of the canvases in the shape of a Z (for the fictional outlaw Zorro). Punning on the Fontana works, and perhaps the weight given to them by art historians, Cattelan's gesture is based on humor, "the comedy of the arts." Although Zorro is associated with the briskly slashed Z, in Spanish *zorro* means "fox," evoking the wily and cunning animal. Isn't the twenty-first-century artist a new evocation of such a trickster?

As an agent provocateur, Cattelan also brings to mind the Italian artist Piero Manzoni, who collaborated with Fontana. Although his career was cut short when he died at the age of twenty-nine in 1963, he was famous for questioning not only the nature of the art object but also the nature of the market that supports it. He created *Living Sculptures* in 1960 by writing his signature onto people's bodies, and a year later he sold *Artist's Shit* in a can. His influence can be seen in Cattelan's early actions involving gallery owners Massimo De Carlo and Emmanuel Perrotin. Cattelan taped De Carlo to a wall in *A Perfect Day*, 1999, and made Perrotin spend his working hours dressed in a pink penis suit in *Errotin, le vrai lapin (Errotin, the True Rabbit)*, 1995–99.

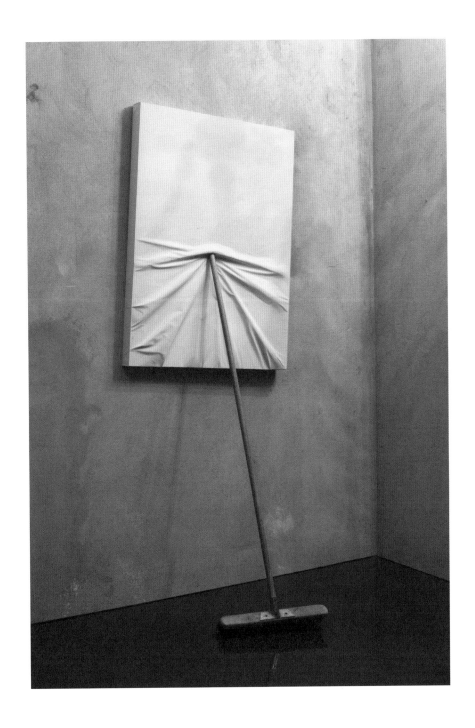

ARTE POVERA

The greatest joy on earth consists in inventing the world the way it is without inventing anything in the process.[13]
—ALIGHIERO E BOETTI

Two of the most important artists associated with Arte Povera are represented here by several works in their trademark styles, which have become symbols of the movement and of the era. In his short lifetime (he died of brain cancer at fifty-three), Alighiero e Boetti produced an astonishing artistic output. This is due, in part, to his collaborations with others in far-reaching places, such as Africa and the Middle East. He was so consumed with duality and pairing that he added *e* (the Italian word for "and") between his first and last names. He also sent picture postcards of himself to his friends in *Gemelli*, which show him and his cloned self holding hands. From the beginning, Boetti worked with collaborators on his art, though most often through an agent, creating a third party in the interaction. "For Boetti, a *handicraft* executed by a third party embodies the interpretation of a collective *score*."[14] Through an agent, Boetti worked for years with Afghan weavers on creating embroidered works, including the two-panel *16 dicembre 2040 11 luglio 2023*, 1971 (PP. 116–17). In this piece the artist mysteriously immortalized the centennial date of his birth and his prediction for when he would die. Sadly, Boetti died much earlier than predicted, in February 1994.

Boetti came to explore a variety of themes and subjects in the embroideries, including airplanes, seemingly abstract collages of recognizable and abstract images in works called *Tutto (Everything)*, 1991–92, thousands of text-based panels, and maps. In *Mappa*, 1989 (PP. 100–01), national flags have been embroidered onto the shapes of their countries on a world map. Three borders of the work contain the Farsi language (spoken in parts of Afghanistan), and the top horizontal border has text in Italian.

The more intimate world of Michelangelo Pistoletto can be seen in what he has called his mirror paintings. In *Stereo (in Four Parts)*, 1962–72 (PP. 96–97), a particularly large example of his work at ten-by-sixteen feet, the body of the viewer assumes central importance, flanked by two stereo speakers painted along the distant vertical edges of the piece. Unlike the works *Due persone (Two People)*, 1963–64 (P. 59), and *Vietnam*, 1965, *Stereo (in Four Parts)* puts the focus squarely on the viewer, not only due to the expanse of mirror reflecting back him or her, but also due to the speakers, which imply that if turned on, they would amplify or echo the viewer's voice. The piece is complete when something or someone is placed in front of it; only then does the subject matter materialize.

Recounting how he first became interested in pursuing a career in art, Cattelan recalls this influential encounter: "I was in Padua, walking to work at the hospital—I was a nurse there—and I saw in the window of this small gallery works by Pistoletto. They looked interesting, so I went in and asked the staff what they were about. They said, 'Are you interested in learning about art?' Then they gave me a few art history books to read. Five years later, I made my first piece."[15]

GIOVANNI ANSELMO
BORN 1934, BORGOFRANCO D'IVREA, ITALY

Invisibile (Invisible), 1971
PROJECTOR AND SLIDE WITH THE WORD "*VISIBILE*"

The artistic act, an essentially individualistic act, becomes part of a more general process when the works are exhibited and creates a site of meaning, research and confrontation.

G.A.

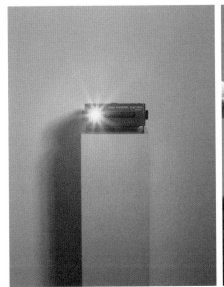

MICHELANGELO PISTOLETTO

BORN 1933, BIELLA, ITALY

Due persone (Two People), 1963–64

GRAPHITE AND OIL ON CUT TRANSPARENT PAPER MOUNTED ON
POLISHED STAINLESS STEEL
78 7/8 X 47 1/4 X 7/8 INCHES

FOLLOWING
M.C.

Untitled, 2009

POLYURETHANIC RUBBER
8 X 4 X 3 INCHES

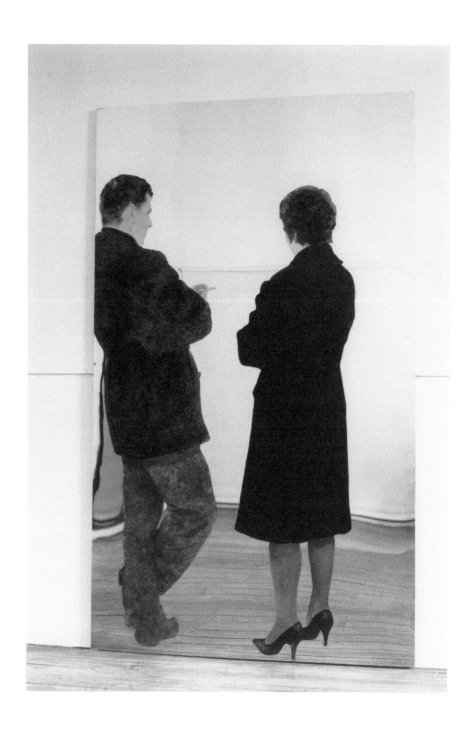

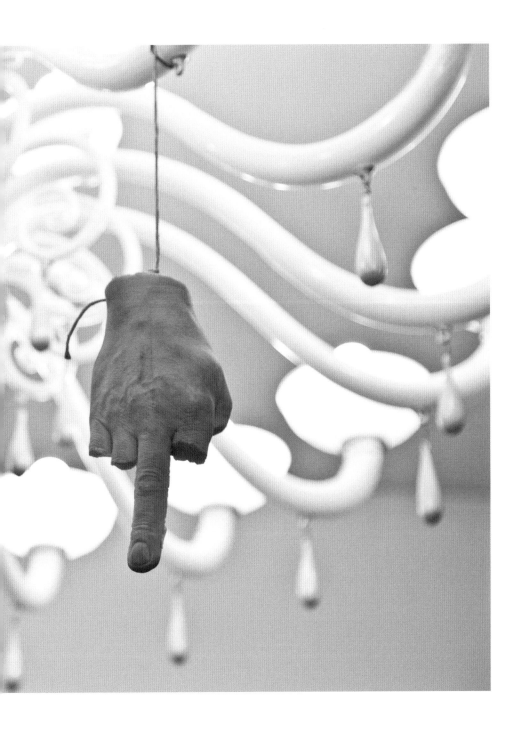

ICONS

Warhol was proof that you can be revolutionary without being militant.[16]
—MAURIZIO CATTELAN

Works by Andy Warhol spanning three decades, *Double Mona Lisa*, 1963, *Mao*, 1973, and *Camouflage Last Supper*, 1986 (PP. 13, 121, AND 80–81 RESPECTIVELY), reflect on popular icons of art history, politics, and religion. The double-portrait of the *Mona Lisa*, originally painted by Leonardo da Vinci in 1503, evokes the ubiquity of mechanical reproduction and the impotence of painting in light of the camera, the printing press, and other new reproductive technologies. The silkscreened image on the left is streaked, smudged, and obviously a later pressing than its partner image on the right. What has this masterpiece become in Warhol's hands: a degraded reproduction, reminiscent of a postcard, or a valuable work of art in its own right? (Is it both? Warhol seems to imply that it is.) Duchamp's earlier appropriation of the *Mona Lisa*, in which he defaced her with a mustache and goatee on a postcard-sized print (as well as in the title of the work, *L.H.O.O.Q.*) is perhaps a more direct high-meets-low-art confrontation, the artist questioning the perceived sanctity of art itself.[17] In Warhol's *Mao* a different sort of challenge to icon status is at work in that the founder of the People's Republic of China was a towering political figure who, in Warhol's hands, becomes merely another celebrity. Warhol took on the more complex business of religion in one of his last significant bodies of work, the *Last Supper* paintings. His many silkscreen variations of da Vinci's masterpiece provided a new way to view the famed painting, exaggerating the many ways in which the work has been adapted for sacred and profane uses. Although Warhol's versions have become high-priced assets themselves—as he well recognized they would—knowing that the artist was a practicing Catholic throughout his life suggests that he was also acknowledging the magnetic power that the five-hundred-year-old image still had and continues to have over people.[18]

While Warhol addressed religion only in the last decade of his life, Cattelan has employed it as a recurrent theme in his work. Save his sculptural presentation of Pope John Paul II felled by a meteorite in *La nona ora (The Ninth Hour)*, 1999, Cattelan, who once said, "Anyone growing up in Italy has a twisted relationship with religion,"[19] produces works with dual and dueling propositions. *Ave Maria*, 2007 (P. 91), for example, is a much quieter, more ambiguous image. On the one hand, the title recalls the traditional Roman Catholic prayer that begins "Hail Mary, Full of Grace, the Lord is with thee." (While seeing the piece, you might imagine the musical accompaniment by Johann Sebastian Bach or Tupac Shakur.) On the other hand, the three disembodied arms extend from the wall in the gesture of a *heil* salute, though the arms are in the sleeves of business suits, not Third Reich military uniforms. This form of salute is said, though this is not proven, to have originated during the Roman Empire, and it was used by Italian fascists after World War I. As is often the case with Cattelan, there are two seemingly oppositional tropes at work in this sculpture: "Images are always ambiguous. I have always worked with their uncertainty, resisting . . . any temptation to tell any absolute truth. . . . The raised arm is for me an extraordinary symbol of power, an erection in potential but also [it requires] the absolute suspension of judgment. No one has ever succeeded in understanding where the Roman salute comes from and who invented it, but the doubt hasn't divested it of its force throughout time. In the end, if I have to choose between two evils, I'll always take the worse."[20]

Opting for the worse perhaps explains Cattelan's motivation for creating *Him*, 2001, a sculpture of a solemn miniature Hitler on his knees, hands clasped in front of him and eyes looking skyward, possibly praying. Is he repentant or trying to save his own skin? In a similar vein, James Lee Byars's *The Halo*, 1985 (P. 73), perplexes with its obvious ambiguity. Is this truly a halo, or is it a gold ring, a symbol of material wealth? As the work resists either of these answers exclusively, it seems to be both at once.

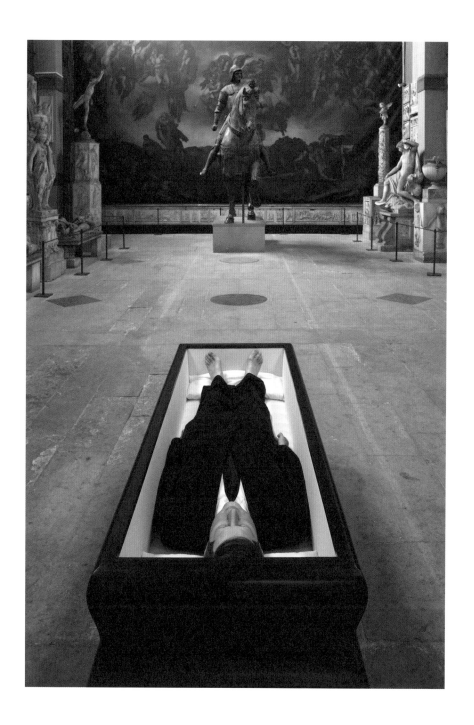

M.C.

Now, 2004

POLYESTER RESIN, WAX, HUMAN HAIR, AND CLOTHES

LIFE-SIZE

Musee d'Art moderne de la ville de Paris/ARC at the Chapelle des Petits Augustins of the
Ecole nationale superieure des Beaux-Arts, Paris

FOLLOWING

M.C.

Novecento (1900), 1997

TAXIDERMIED HORSE, LEATHER SADDLERY, ROPE, AND PULLEY

78 ⅞ X 105 ⅞ X 27 INCHES

Castello di Rivoli, Museo d'Arte Contemporanea, Turin

Even more enigmatic with its overt religious symbolism packaged in ordinary trappings, *Untitled*, 2007 (P. 115), depicts a woman seemingly crucified inside an art crate. Originally conceived for the Synagogue Stommeln Art Project in Pulheim, a small town northwest of Cologne in Germany, the work shows a woman whose arms are splayed upward; her head is tilting or falling to the left, and her ankles, torso, and wrists are secured tightly by braces. Earlier in 2007, Cattelan had created another sculpture of a woman from a 1977 photographic self-portrait by Francesca Woodman. Here, the figure is hanging from a doorway, grasping the hinges at the top of the molding. Her body is facing the viewer, so she could look the viewer in the eyes if she wanted to, but instead she turns away. While that work was being packed for shipping, Cattelan saw it in the crate and decided that it made a better piece facing down, which resulted in the current crated version. According to Cattelan, "Woodman's photograph was the starting point that took me from point A to point B."[21] As with *La nona ora*, the sculpture has been labeled blasphemous by its critics. Cattelan is dismayed by such reactions to his pieces: "I would have never created *La nona ora* if I knew that people would think that. The piece is about my need to detach myself from my father, a process adults go through. I initially made the piece so that the figure was standing up, and then I went to look at it later and thought, 'This is silly, too sentimental.' I wanted to destroy it, but the people putting on the exhibition didn't want me to."[22] Feeling that it needed to make a stronger statement about breaking away from one's father, Cattelan wanted to depict the figure being destroyed, but felt that "man cannot kill the Pope, only an act of God can."[23] That is when the meteorite came into play . . . or not.[24]

In an untitled sculpture from 2007, the ass of a horse juts from the wall above the viewer's head (P. 99). The horse's head is stuck into the wall just far enough to support the suspended body. This equine contrasts with two earlier ones in the artist's oeuvre, *The Ballad of Trotsky*, 1996, and *Novecento (1900)*, 1997 (PP. 68–69). These latter two pieces are weighed down not only by the way they are mounted—suspended from their midsections with their legs dangling down and their stomachs pulled up by a harness—but also by their names, which respectively reference the Marxist revolutionary and the twentieth century. *Novecento* in Italian both refers to the twentieth century and is the title of a Bernardo Bertolucci film that examines the rise of fascism in Italy in the first half of the century. *Novecento* has also been used to identify an artistic movement based on classical art founded in Italy in the early 1920s by critic Margherita Sarfatti and seven artists,[25] which later became associated with fascism and its attendant counterpart, communism. The horse with the hidden head, *Untitled*, 2007, is light in comparison to the earlier sculptures. It looks as if it could fly. It is defying gravity, unlike the harnessed horses, which are more akin in their droopy heaviness to Morris's felt sculptures. The animal is perhaps camera shy as it hides from the viewer in the same way the ostrich does in Cattelan's *Untitled*, 1997, shown in the exhibition "Fatto in Italia," 1997.

The artist recently completed a fourth work involving a horse, making this subject a significant theme in his career to date. Rarely in his oeuvre does a form recur so often, but the horse has been a persistent sight, along with its cousin, the donkey. Between 1994 and 2004, the artist realized four installations with donkeys, including *Warning! Enter at your own risk. Do not touch, do not feed, no smoking, no photographs, no dogs, thank you*, 1994, Cattelan's first solo exhibition in New York at the Daniel Newburg Gallery, which featured a live donkey. That exhibition was an early acknowledgment of his Italian

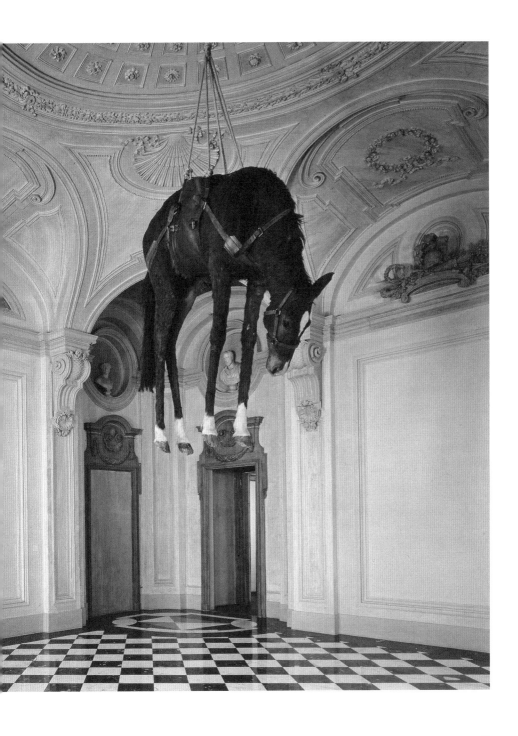

and Conceptual Art forebears, including, among others, Gino De Dominicis and Beuys, who continue to resonate for him and his work. In 1970, De Dominicis organized an installation, *The Zodiac*, which was a performance largely comprising people and animals placed in the positions of the zodiac signs. Beuys spent three days in a room with a coyote in his famous action *I Like America and America Likes Me*, 1974. But, unlike in works by De Dominicis and Beuys, there is a certain leavening of sobriety in Cattelan's work; a sense of humor comes into play in a way that those earlier but equally poetic gestures could not attain. Of course, Cattelan's animal, the ass, is an almost universal symbol of foolishness.

With Cattelan's newest horse sculpture, *Untitled*, 2009 (PP. 86–87), the horse is not suspended from the ceiling or flying, but lies prostrate. You do not look up at it in awe, amazed at its sheer weight and size, dangling above your head, but rather you pity it as it lies dead, resting at your feet. This horse, unlike the others, is accompanied by language: the acronym "INRI" is written on a sign attached to a stake, which is lodged in the carcass. Short for the Latin phrase *Iesus Nazarenus Rex Iudaeorum*, which translates as "Jesus of Nazareth, King of the Jews," INRI is most often seen on titular plaques accompanying images of the Crucifixion. But what cause did this horse die for? Or is Cattelan once again offering up humor-meets-gravitas by contrasting the brutality and futility of Christ's death with the old adage, "Never beat a dead horse"?

NOTES

1. Maurizio Cattelan, quoted in Kate Zamet and Sherman Sam, "Artworker of the Week #12," *kultureflash*, June 24, 2003, http://www.kultureflash.net/archive/49/priview.html.

2. Although the phrase could relate to any common usage, it is also the title for the 1969 exhibition by Harald Szeemann "Live in Your Head: When Attitudes Become Form." The innovative exhibition was one of the first to recognize and acknowledge the process of creation as a work of art. It was also one of the first truly global shows of contemporary art.

3. Maurizio Cattelan, quoted in Andrea Bellini, "An Interview with Maurizio Cattelan," *Sculpture* 24, no. 7 (2005), http://www.sculpture.org/documents/scmag05/sept_05/webspecs/cattelanenglish.shtml.

4. Maurizio Cattelan, conversation with the author, October 7, 2009.

5. Maurizio Cattelan, quoted in Hans Ulrich Obrist, *Hans Ulrich Obrist: Interviews*, Vol. 1, ed. Thomas Boutoux (Milan: Charta, 2003), 145.

6. Ibid., 152.

7. Francesco Bonami, "Static on the Line: The Impossible Work of Maurizio Cattelan," in *Maurizio Cattelan*, ed. Francesco Bonami, et. al. (London: Phaidon Press, 2000), 40.

8. Maurizio Cattelan, quoted in interview with Michele Robecchi, *Interview*, June 8, 2009.

9. Although the de Menils were purchasing twentieth-century work that was made in Africa and the Pacific Islands as well, in most cases they did not know the identity of the artists who created the works, nor did they travel to the places in which the works were made.

10. Robert Morris, "Anti Form," *Artforum* 6, no. 8 (1968), 35.

11. Maurizio Cattelan, quoted in "Nancy Spector in Conversation with Maurizio Cattelan," in *Maurizio Cattelan*, 18–22.

12. Erika Billeter, *Lucio Fontana, 1899–1968: A Retrospective*, exh. cat. (New York: Solomon R. Guggenheim Foundation, 1977), 13.

13. *Alighiero Boetti: Mettere al mondo il mondo (Alighiero Boetti: Bringing the World into the World)*, exh. cat. (Frankfurt: Museum für Moderne Kunst, 1998), 297.

14. Lynne Cooke and Karen Kelly, *Worlds Envisioned: Alighiero e Boetti and Frédéric Bruly Bouabré*, exh. cat. (New York: Dia Center for the Arts, 1995), 64.

15. Cattelan, conversation with the author.

16. Cattelan, quoted in Robecchi.

17. When said aloud in French, the letters L.H.O.O.Q. seem to create the sentence "*Elle a chaud au cul*," loosely translated as, "She has a hot ass."

18. The force of images has long been a hot topic among art scholars. In particular, W.J.T. Mitchell argues: "I believe that magical attitudes towards images are just as powerful in the modern world as they were in so-called ages of faith. I also believe that the ages of faith were a bit more skeptical than we give them credit for. My argument here is that the double consciousness about images is a deep and abiding feature of human responses to representation. It is not something that we 'get over' when we grow up, become modern, and acquire critical consciousness." W.J.T. Mitchell, *What Do Pictures Want?* (Chicago: University of Chicago Press, 2005), 8.

19. Maurizio Cattelan, quoted in Calvin Tomkins, "The Prankster," *The New Yorker*, October 4, 2004, 80.

20. Maurizio Cattelan, quoted in Helena Kontova, "Maurizio Cattelan: No Cakes for Special Occasions," *Flash Art* 40, no. 257 (2007), 76.

21. Cattelan, conversation with the author.

22. Ibid.

23. Ibid.

24. In other statements, the artist has refuted the story of how *La nona ora* was made: "Some artworks come with a story, and you never know if the story is true or false. I always tell this story that my pope wasn't supposed to be lying down. He was meant to be standing, and then we spread the rumor that it was a last-minute decision to change the position of the sculpture and throw in the meteorite. I don't even know if this is exactly a rumor. It has to do more with misinformation. I like to package artworks with an enormous amount of fake information, so that at the end there is no truth." Cattelan, quoted in Obrist, 144.

25. The seven artists who co-founded Novecento Italiano with Margherita Sarfatti are Anselmo Bucci, Leonardo Dudreville, Achille Funi, Gian Emilio Malerba, Piero Marussig, Ubaldo Oppi, and Mario Sironi.

JAMES LEE BYARS

BORN 1932, DETROIT, MICHIGAN; DIED 1997

The Halo, 1985

GILDED BRASS
OVERALL: DIAMETER 86½ INCHES
BRASS: DIAMETER 8 INCHES

PAUL TAYLOR: *What sort of artist are you?*

JAMES LEE BYARS: *You tempt my tongue. Well, at least a good artist.*

PAUL TAYLOR: *Michael Werner [your dealer] told me . . . that a lot of American art is materialistic, but that you, although American, make art that's immaterial, antimaterialistic?*

JAMES LEE BYARS: *What is material? The question is moot. Is thought a material?*

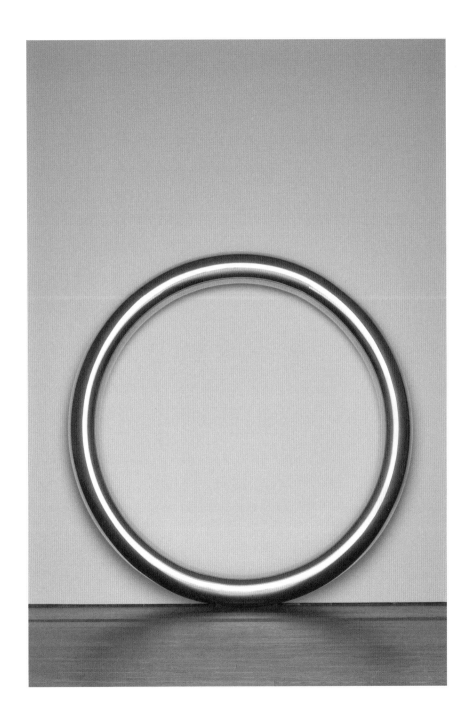

M.C.

Daddy, Daddy, 2008

POLYURETHANE RESIN, STEEL, AND EPOXY PAINT

10 X 43 X 38 INCHES

"theanyspacewhatever," Solomon R. Guggenheim Museum, New York

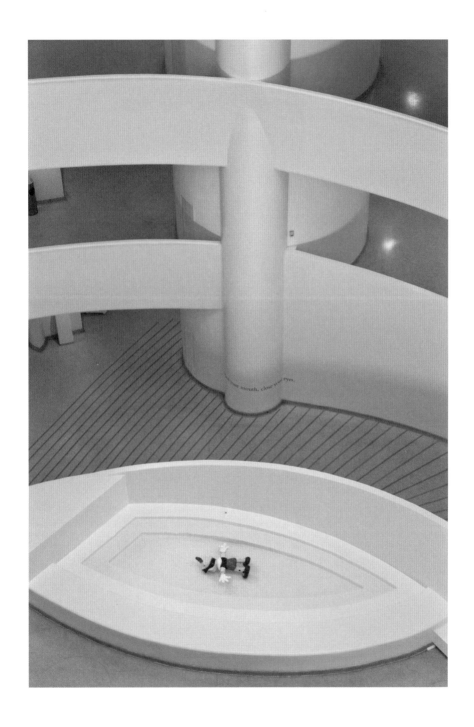

BRUCE NAUMAN

BORN 1941, FORT WAYNE, INDIANA

Untitled, 1965

FIBERGLASS, POLYESTER RESIN, AND NEON TUBING
4 X 6 X 79 INCHES

Of course, there is a kind of logic and structure in art-making that you can see as game playing. But game-playing doesn't involve any responsibility—any moral responsibility—and I think that being an artist does. . . . With a game you just follow the rules. But art is like cheating—it involves inverting the rules or taking the game apart and changing it.

B.N.

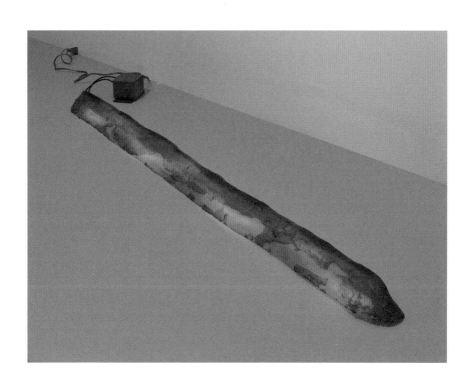

M.C.

Untitled, 1999

CLOTHES

LIFE-SIZE

FOLLOWING

ANDY WARHOL

Camouflage Last Supper, 1986

SILKSCREEN INK ON SYNTHETIC POLYMER PAINT ON CANVAS

78 X 306 INCHES

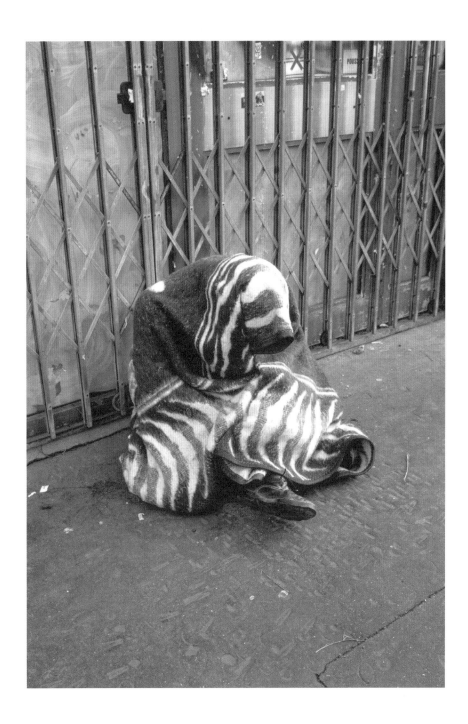

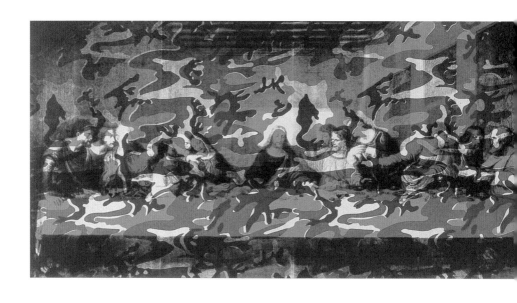

80

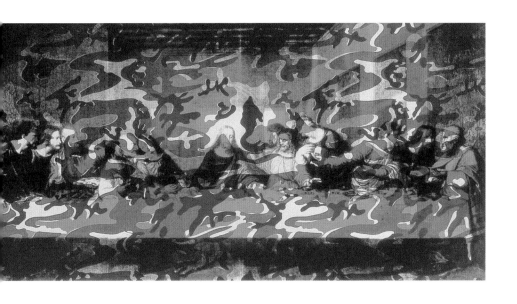

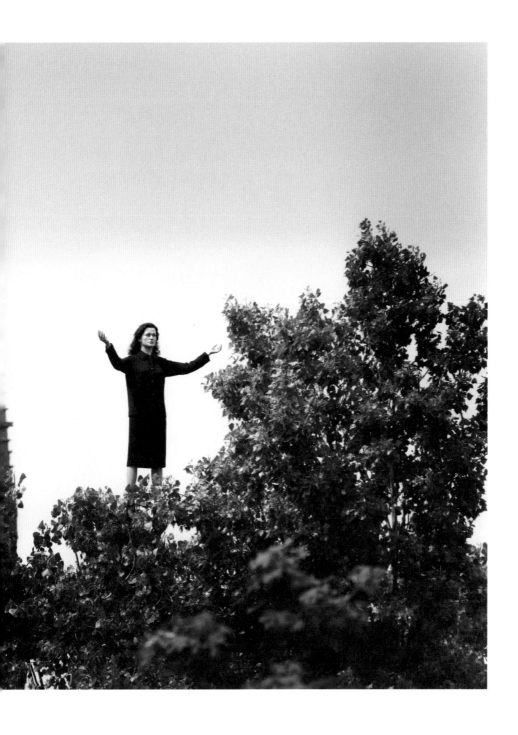

PREVIOUS
M.C.

Frau C., 2007

FIBERGLASS, HAIR, AND CLOTHES
LIFE-SIZE
Portikus Museum, Frankfurt

JASPER JOHNS
BORN 1930, AUGUSTA, GEORGIA

Untitled [Green Painting], 1954

OIL ON PAPER MOUNTED ON CANVAS
9 X 9 INCHES

It all began with my painting a picture of an American Flag. Using this design took care of a great deal for me because I didn't have to design it. So I went on to similar things like the target — things the mind already knows. That gave me room to work on other levels. For instance, I've always thought of a painting as a surface; painting it in one color made this very clear. Then I decided that looking at a painting should not require a special kind of focus like going to church. A picture ought to be looked at the same way you look at a radiator.

J.J.

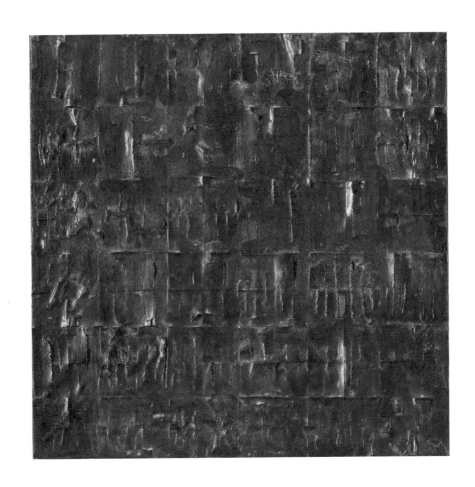

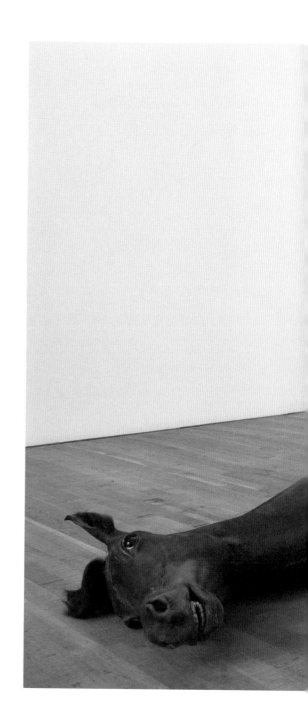

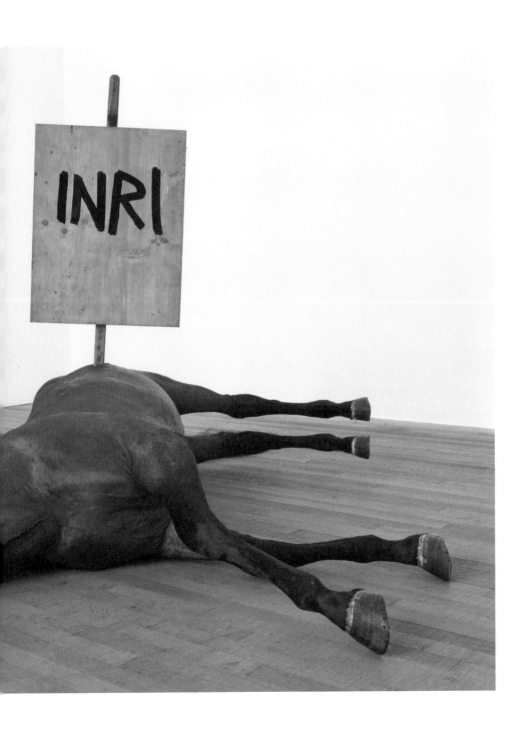

M.C.

Untitled, 2009

TAXIDERMIED HORSE, WOOD, AND PAINT

LIFE-SIZE

"Pop Life. Art in a Material World," Tate Modern, London

JOSEPH KOSUTH

BORN 1945, TOLEDO, OHIO

Titled (Art as Idea as Idea) [meaning], ca. 1967

PHOTOSTAT ON PAPER MOUNTED ON WOOD

47 X 47 INCHES

A simplistic scenario puts the artistic struggle in this century between Pablo Picasso and Marcel Duchamp. If one wants to understand the art of the next century, one understands that Picasso made 'masterpieces,' and he belongs to the collectors; and Duchamp didn't, and he belongs to the artists.

J.K.

mean·ing (mēn′iŋ), *n.* 1. what is meant; what is intended to be, or in fact is, signified, indicated, referred to, or understood: signification, purport, import, sense, or significance: as, the *meaning* of a word. 2. [Archaic], intention; purpose. *adj.* 1. that has meaning; significant; expressive.

M.C.

Ave Maria, 2007

POLYURETHANE AND METALLIC PARTS, CLOTHES, AND PAINT

APPROXIMATELY 18 X 29 X 46 INCHES

Tate Modern, London

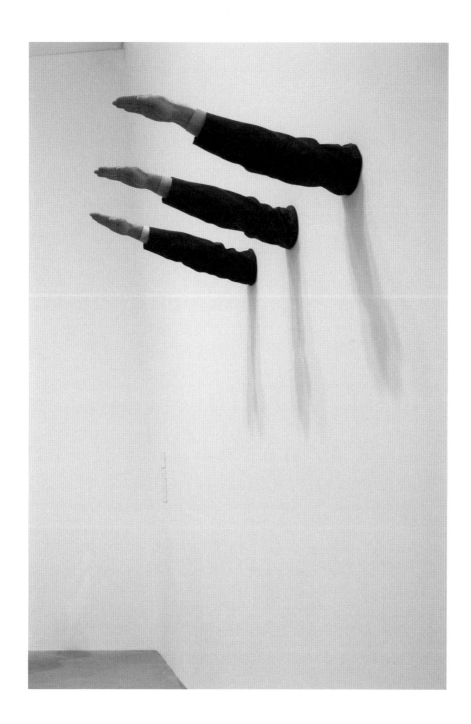

ROBERT RAUSCHENBERG

Glacier (Hoarfrost), 1974

SOLVENT TRANSFER ON SATIN AND CHIFFON WITH PILLOW
120 X 74 X 5⅞ INCHES

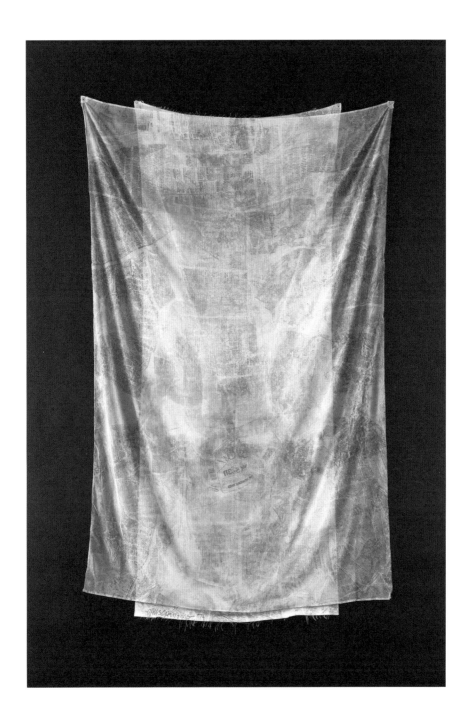

M.C.

Untitled, 2000

BLACK-AND-WHITE PHOTOGRAPH, DIGITAL PRINT ON PAPER
16⅜ X 13 INCHES

FOLLOWING
MICHELANGELO PISTOLETTO

Stereo (in Four parts), 1962–72

PAINTED TISSUE PAPER ON STAINLESS STEEL MOUNTED ON STEEL FRAME
EACH 90½ X 47¼ INCHES

I'm not writing for tired, lazy people, without a future, without desires, without ambitions; I'm not writing for them. Writing is not doing a good deed. It's not music for the deaf. I'm writing for people in good health, strong, sanguine people. I'm writing for Parma hams; I'm writing for sausage and sauerkraut. I'm writing Russian salad and spaghetti and tomato sauce in the same dish. I'm writing for the Italian well-to-do, laborers or peasants who love hot sauce with their boiled meat.

These lines smell of garlic a mile away; they smell of grappa.

M.P.

M.C.

Untitled, 2007

TAXIDERMIED HORSE
118 ⅛ X 66 ⅞ X 31 ½ INCHES; WEIGHT 176 LBS.
MMK Museum für moderne Kunst, Frankfurt am Main

FOLLOWING
ALIGHIERO E BOETTI

Mappa, 1989

EMBROIDERY ON CLOTH
47 ⅝ X 87 INCHES

I have worked a lot with the concept of order and disorder: either by disturbing order . . . or by presenting visible disorder as representative of an intellectual order. . . . It is simply a question of knowing the rules of the game: those who do not know them will never be able to perceive the order behind things; for example, if you do not know the order of the stars, when you look up at the firmament all you see is chaos, whereas an astronomer has a very clear insight into things.

A.E.B.

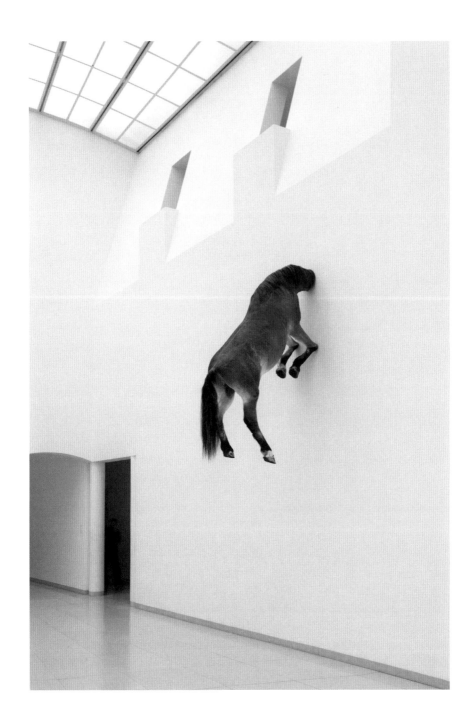

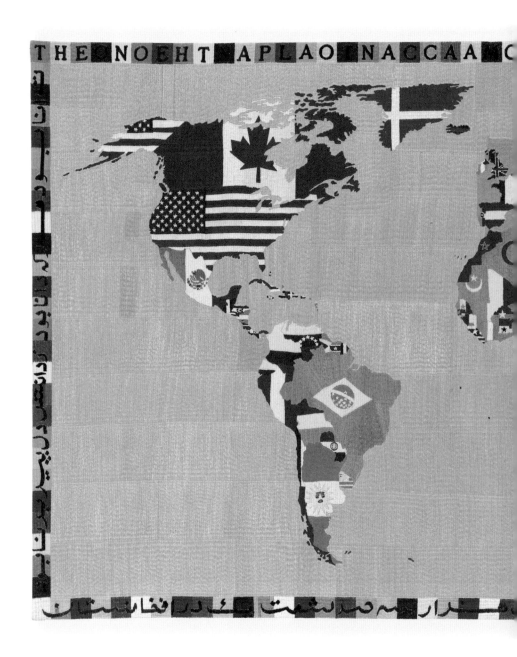

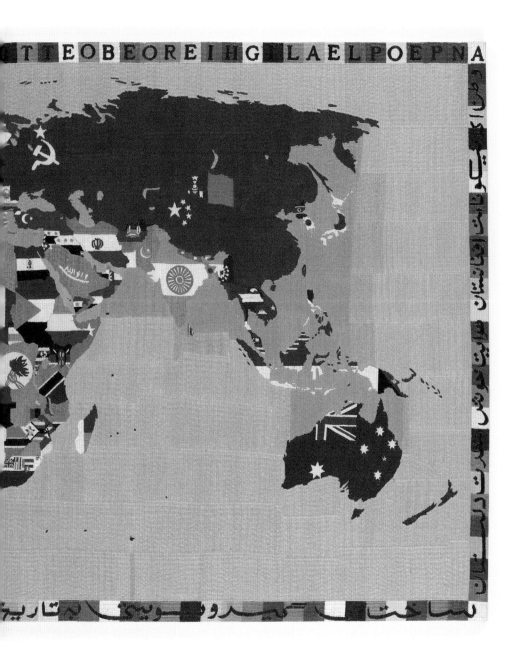

101

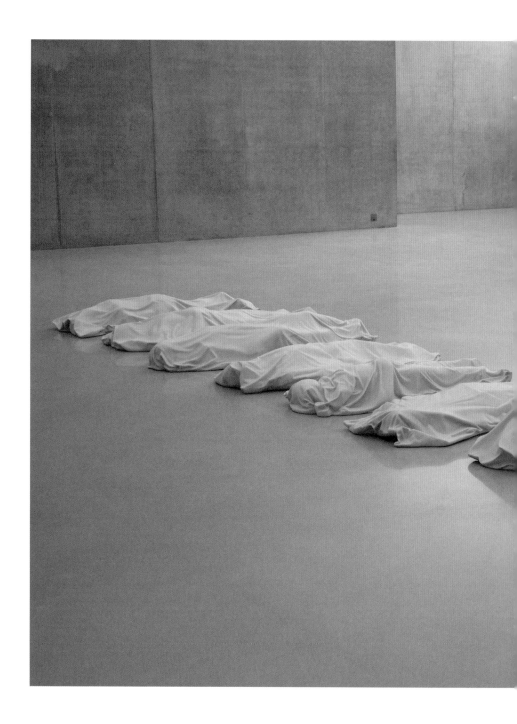

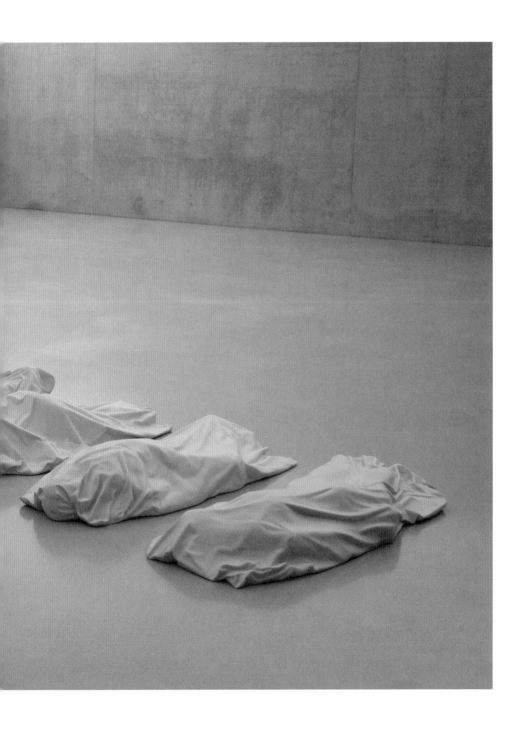

PREVIOUS
M.C.

All, 2007

WHITE P CARRARA MARBLE
316 X 79 INCHES
Kunsthaus Bregenz, 2nd floor, Bregenz, Austria

LUCIO FONTANA

Concetto spaziale (Spatial Concept), 1960 – 62

OIL ON CANVAS
25 ½ X 19 ¾ INCHES

FOLLOWING
M.C.

Untitled, 2008

BOOTS AND PEPPER PLANTS
15 ¾ X 11 ¾ X 11 ¾ INCHES
Synagogue Stommeln Art Project, Pulheim – Stommeln, Germany

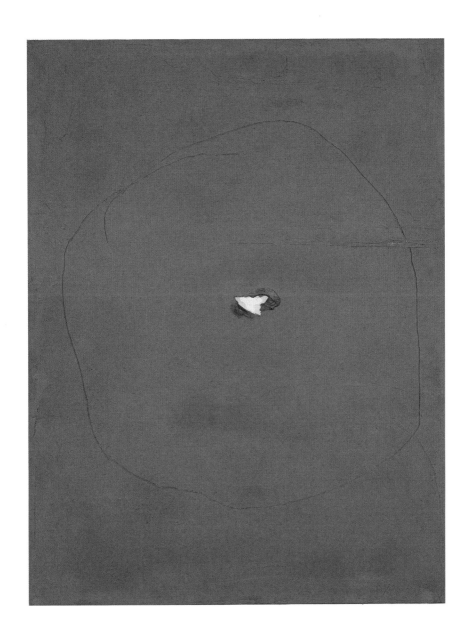

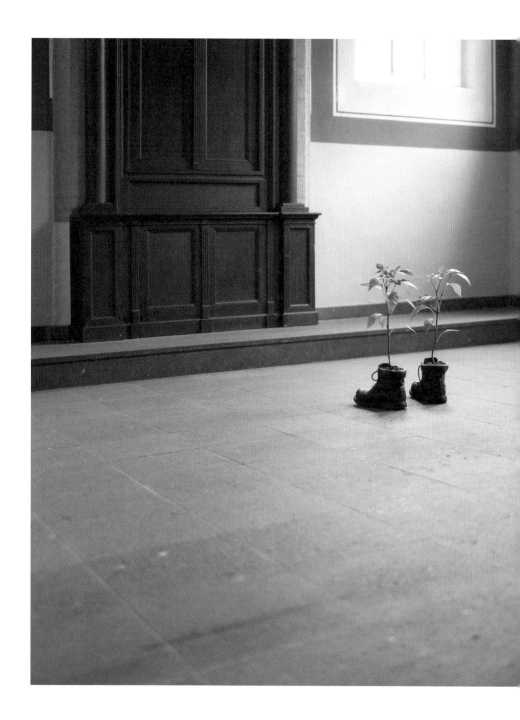

ANDY WARHOL

Little Race Riot, 1964

SILKSCREEN INK ON LINEN
30 ⅛ X 33 INCHES

I used to think that everything was just being funny. But now I don't know. I mean, how can you tell? I can't tell if a person is just being funny or if they're really crazy.

A.W.

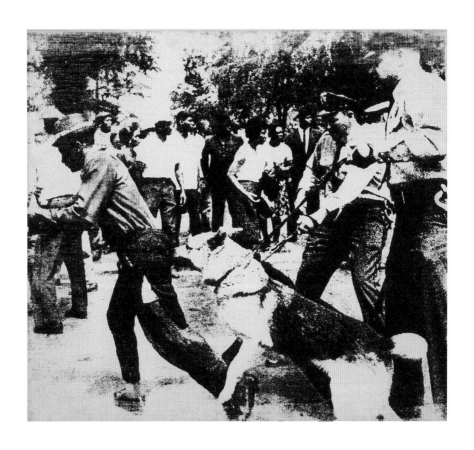

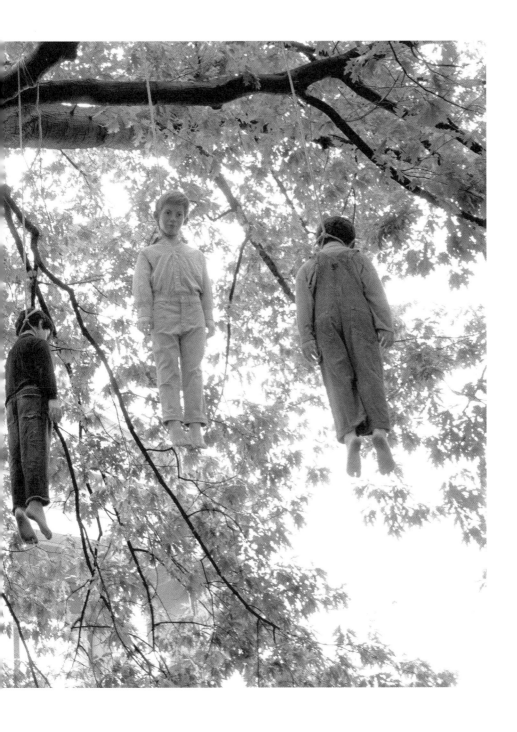

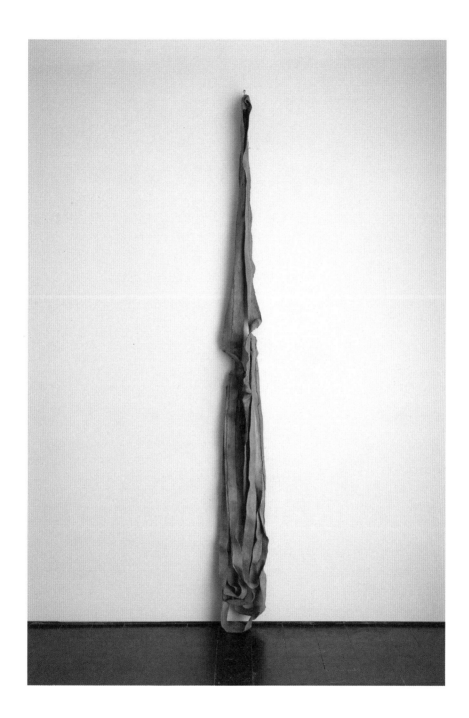

M.C.

Untitled, 2007

RESIN, CLOTHES, HAIR, AND WOOD
94 ½ X 55 ⅛ X 27 ½ INCHES

FOLLOWING
ALIGHIERO E BOETTI

16 dicembre 2040 11 luglio 2023, 1971

EMBROIDERY ON CLOTH
TWO PARTS, EACH 24 ⅛ X 24 ⅛ INCHES

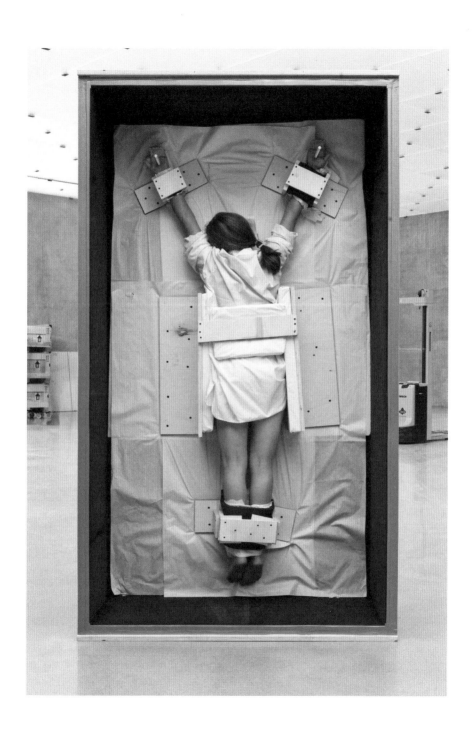

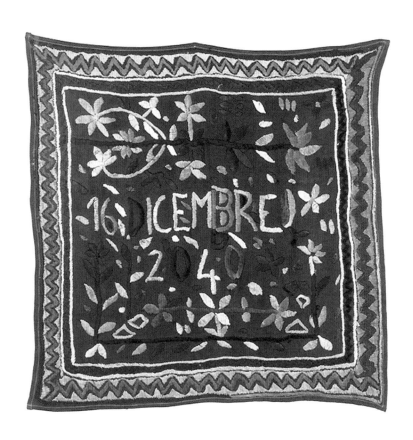

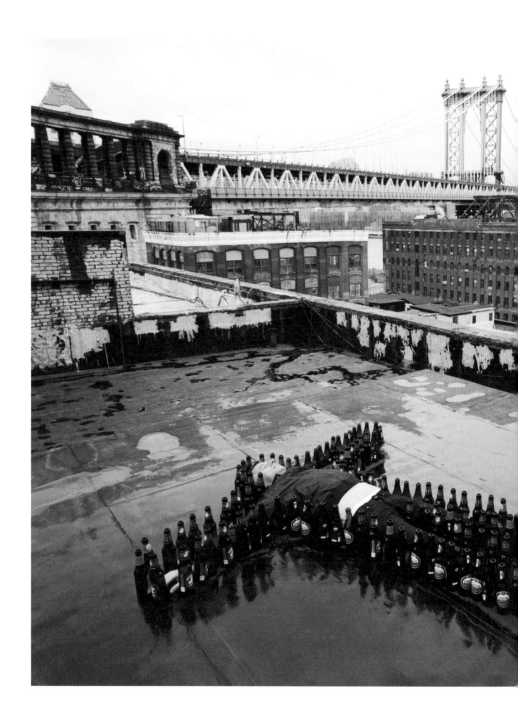

NEW YORK, NEW YORK, 2007

ANDY WARHOL

Mao, 1973

ACRYLIC AND SILKSCREEN INK ON CANVAS
12 1/16 X 10 INCHES

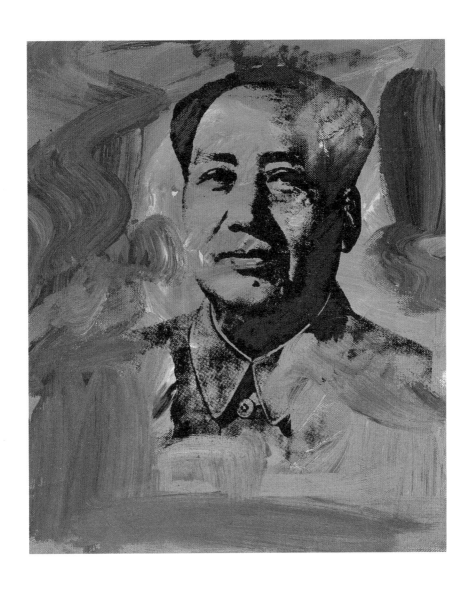

ACKNOWLEDGMENTS

JOSEF HELFENSTEIN

It was a great pleasure for us at the Menil Collection to have worked with Maurizio Cattelan, one of the most important contemporary artists practicing today. I am grateful for his enthusiasm and dedication to this project.

My sincere appreciation goes to Gallerist Marian Goodman, Managing Director Elaine Budin, Archivist Catherine Belloy, and Registrar Brian Loftus, all at the Marian Goodman Gallery, New York, who generously aided us by facilitating key loans, sharing their archives, and providing valuable assistance. Ali Rosenbaum of Giraud Pissarro Segalot, New York, also provided us with key support in procuring loans.

I am deeply indebted to those who lent works by Cattelan for this exhibition, which include the artist, with the assistance of Lucio Zotti, Milan; the Rachofsky Collection, Dallas; the Irma and Norman Braman Collection, Miami; and the Steven and Alexandra Cohen Collection, New York. Michael and Nina Zilkha, Houston, have also generously lent several works by Arte Povera artists from their collection.

I am truly grateful to the Menil Collection's Board of Trustees and its President, Harry Pinson, as well as its Chairman, Louisa Stude Sarofim, for their dedication to this exhibition. Special recognition must also go to Franklin Sirmans, the Menil's Curator of Modern and Contemporary Art from 2006 to 2009 and currently the Terri and Michael Smooke Department Head and Curator of Contemporary Art at the Los Angeles County Museum of Art, whose ongoing relationship with the artist led to the realization of this exhibition. Franklin's efforts were tirelessly supported by Melanie Crader and Chelsea Beck, as well as others in the Menil's Curatorial Department: Bernice Rose, Kristina Van Dyke, Michelle White, and Clare Elliot.

The exhibition would not have been possible without the continued excellence and participation of the Menil staff: Anne C. Adams, John C. Akin, Geraldine Aramanda, Patrice A. Ashley, Adam R. Baker, Oliver Mathais Bakke III, Lisa Barkley, Katrina A. Bartlett, Jocelyn Elaine Bazile, Tobin B. Becker, Peter D. Bernal, Melissa M. Brown, Delana A. Bunch, Janice Burandt, Sabina Causevic, Erh-Chun A. Chien, Peter Cohen, Margaret Elsian Cozens, William Cuevas, Lisa M. Delatte, Kenneth S. Dorn, Stuart L. Dulek, Brenda G. Durden, Ralph W. Ellis, Bradford A. Epley, Susan Epley, Ernest Flores, Marta

Galicki, Latisha S. Gilbert, Earline Gray, J.D. Griffin, Barbara Grifno, Vera Hadzic, Judith M. Hastings, Dawn Hawley, Katherine R. Heinlein, Jennifer Hennessy, Shawnie E. Hunt, Anthony O. Igwe, Alem Z. Imru, Mary L. Kadish, Karl Kilian, Clifford King Jr., Shablis Kinsella, Judy M. Kwon, Brian LaFleur, Brian Lantz, Guillermo S. Leguizamon, Shiow-Chyn Liao, Thomas J. Madonna, Suzanne M. Maloch, Rita Marsales, Anthony Martinez, Sylvester Martinez, Steve A. McConathy, Ebony McFarland, Sharon McGaughey, Alvin B. McNear Jr., Erma J. McWell, Getachew Mengesha, Vance Muse III, Kathleen Oria, Mohammed Osman, Lori Paredes, Adriana Perez, Patrick J. Phipps, Nancy Kate Prescott, Timothy Quaite, Lajeanta A. Rideaux, Laura E. Rivers, Sarah Robinson, Antonio Rubio, Kristin Schwartz-Lauster, Irvin K. Semiens, Amanda Shagrin, Mirzama Sisic, Roy A. Skorupinski, Thelma Smith, Brooke M. Stroud, Konjit T. Tekletsadik, Emily Todd, Maurice Truesdale, Thomas F. Walsh, Timothy D. Ware, and Aline Wilson.

Guided by the editorial expertise of Menil Publisher Laureen Schipsi, this publication is a testament to the hard work and intellectual might of several people, including Jennifer Hall and Sean Nesselrode, also of the Publications Department. Purtill Family Business has contributed a discerning design that benefits from his prior work on Cattelan's publications. I wish to thank Caitlin Haskell for her important contributions to the catalogue and Maia Toteva for her feedback on the texts; both are Vivian L. Smith Foundation Fellows at the Menil Collection. Curatorial assistant Mary Lambrakos also provided invaluable research early in the process of organizing the catalogue and the show.

Lastly, my most sincere gratitude goes to our sponsors, without whose generous support this exhibition could not have occurred: Marion Barthelme and Jeff Fort; Frances Dittmer; Barbara and Michael Gamson; William J. Hill; Jackson and Company; Sotheby's; The Stardust Fund; Nina and Michael Zilkha; the Istituto Italiano di Cultura, Los Angeles, directed by Francesca Valente; and the City of Houston.

ONLINE RESOURCES

For an exhibition history and biographical information on the artist, refer to
www.mauriziocattelan.org.

CREDITS

The artist wishes to thank Galerie Emmanuel Perrotin, Paris; Galleria Massimo De Carlo, Milan; and
Marian Goodman Gallery, New York, for their contributions to the exhibition and catalogue. Unless
otherwise noted, all works by Maurizio Cattelan, © Maurizio Cattelan.

pp. 2–3: Courtesy Giraud Pissarro Segalot, New York. Photo: Zeno Zotti. p. 7: Lucio Fontana, © 2009
Artists Rights Society (ARS), New York / SIAE, Rome. The Menil Collection, Houston. Photo:
Hester + Hardaway, Houston. p. 13: Andy Warhol, © 2009 The Andy Warhol Foundation for the
Visual Arts, Inc. / Artists Rights Society (ARS), New York. The Menil Collection, Houston. Photo:
Hickey-Robertson, Houston. pp. 14–15: The Steven and Alexandra Cohen Collection. Photo: Markus
Tretter, courtesy Kunsthaus Bregenz. p. 17: Art © Estate of Robert Rauschenberg / Licensed by VAGA,
New York, NY. The Menil Collection, Houston, purchased with funds contributed by The Brown
Foundation, Inc., Scaler Foundation, Inc., The Search Foundation, and the following individuals:
Christophe de Menil, Frances Dittmer, James A. Elkins, Jr., Windi Grimes, Agnes Gund, Walter
Hopps, Adelaide de Menil Carpenter, Janie C. Lee, Roy Nolen, Francesco Pellizzi, Harry Pinson,
Louisa Stude Sarofim, George Stark, Charles Bagley Wright III, and Michael Zilkha. Photo: George
Hixson, Houston. p. 21: © Ed Ruscha. Courtesy Gagosian Gallery. The Menil Collection, Houston.
Photo: George Hixson, Houston. p. 23: Private Collection. Photo: Zeno Zotti, courtesy Giraud Pissarro
Segalot, New York. p. 29: Alighiero e Boetti, © 2009 Artists Rights Society (ARS), New York / SIAE,
Rome. Private Collection, Houston, TX. Photo: © Tom Powel Imaging, courtesy Sperone Westwater,
New York. p. 37: The Rachofsky Collection. Photo: Michael Bodycomb. p. 41: © 2009 Robert Morris
/ Artists Rights Society (ARS), New York. The Menil Collection, Houston. Photo: Hickey-Robertson,
Houston. p. 45: Photo: A. Burger, Zürich. p. 49: The Menil Collection, Houston. Photo: Douglas
Parker. p. 51: Lucio Fontana, © 2009 Artists Rights Society (ARS), New York / SIAE, Rome. The
Menil Collection, Houston. Photo: Paul Hester, Houston. p. 57: Private Collection, Houston, TX.
Courtesy of the Anselmo Archives. Photo: Paolo Mussat Sartor. p. 59: Michelangelo Pistoletto, cour-
tesy of the artist, Luhring Augustine, New York, and Galleria Christian Stein, Milan. The Menil
Collection, Houston. Photo: Paul Hester, Houston. p. 73: © James Lee Byars. The Menil Collection,
Houston. Photo: Hester + Hardaway, Houston. p. 77: © 2009 Bruce Nauman / Artists Rights Society
(ARS), New York. The Menil Collection, Houston, anonymous gift. Photo: © Ben Blackwell, courtesy
Sperone Westwater, New York. pp. 80–81: © 2009 The Andy Warhol Foundation for the Visual Arts,
Inc. / Artists Rights Society (ARS), New York. The Menil Collection, Houston, gift of The Andy
Warhol Foundation for the Visual Arts, Inc. Photo: Paul Hester, Houston. p. 85: Art © Jasper Johns /
Licensed by VAGA, New York, NY. The Menil Collection, Houston. Photo: Hickey-Robertson,
Houston. p. 89: © 2009 Joseph Kosuth / Artists Rights Society (ARS), New York. The Menil
Collection, Houston. Photo: Hickey-Robertson, Houston. p. 93: Art © Estate of Robert Rauschenberg
/ Licensed by VAGA, New York, NY. The Menil Collection, Houston. Photo: Hickey-Robertson,

Houston. pp. 96–97: Michelangelo Pistoletto, courtesy of the artist, Luhring Augustine, New York, and Galleria Christian Stein, Milan. Private Collection, Houston, TX. pp. 100–01: Alighiero e Boetti, © 2009 Artists Rights Society (ARS), New York / SIAE, Rome. Private Collection, Houston, TX. Photo: © Tom Powel Imaging, courtesy Sperone Westwater, New York. pp. 102–03: Private Collection, courtesy Giraud Pissarro Segalot, New York. Photo: Markus Tretter, courtesy Kunsthaus Bregenz. p. 105: Lucio Fontana, © 2009 Artists Rights Society (ARS), New York / SIAE, Rome. The Menil Collection, Houston. Photo: Paul Hester, Houston. p. 109: © 2009 The Andy Warhol Foundation for the Visual Arts, Inc. / Artists Rights Society (ARS), New York. The Menil Collection, Houston. Photo: Hester + Hardaway, Houston. pp. 110–11: Commissioned and produced by Fondazione Nicola Trussardi, Milan. p. 113: © 2009 Bruce Nauman / Artists Rights Society (ARS), New York. The Menil Collection, Houston, gift of the Gerard Junior Foundation. Photo: Hickey-Robertson, Houston. p. 115: Collection of Irma and Norman Braman, Florida. pp. 116–17: Alighiero e Boetti, © 2009 Artists Rights Society (ARS), New York / SIAE, Rome. Private Collection, Houston, TX. Photo: © Tom Powel Imaging, courtesy Sperone Westwater, New York. pp.118–19: Photo: Jungen Frank. p. 121: © 2009 The Andy Warhol Foundation for the Visual Arts, Inc. / Artists Rights Society (ARS), New York. The Menil Collection, Houston, gift of the artist. Photo: Janet Woodard.

NOTES FOR "FROM THE ARTISTS"
Giovanni Anselmo, "The Context of Art / The Art of Context." *Kunst & Museumjournaal* 7, nos. 1–3 (1996), 57. Alighiero e Boetti, quoted in Lynne Cooke, "Jeu d'Esprit," in *Worlds Envisioned: Alighiero e Boetti and Frédéric Bruly Bouabré*, eds. Lynne Cooke and Karen Kelly, exh. cat. (New York: Dia Center for the Arts, 1995), 47. James Lee Byars, quoted in Paul Taylor, "An Interview with James Lee Byars," *Flash Art*, no. 125 (1985–1986), 57. Maurizio Cattelan, quoted in Katy Siegel, "Army of One," *Artforum* 43, no. 2 (2004), 149. Lucio Fontana, et al., *Primo Manifesto dello Spazialismo* (May 1947), quoted in Germano Celant, *The Italian Metamorphosis, 1943–1968*, exh. cat. (New York: The Solomon R. Guggenheim Museum, 1995), 713. Jasper Johns, quoted in "His Heart Belongs to Dada," *Time* 73 (May 4, 1959), 58, quoted in Kirk Varnedoe, ed., *Jasper Johns: Writings, Sketchbook Notes, Interviews* (New York: Museum of Modern Art, 1996), 82. Joseph Kosuth, "On Masterpieces," unpublished response to questionnaire by the Musée de l'Art Moderne, Paris (1985), quoted in Gabriele Guercio, ed., *Art After Philosophy and After: Collected Writings, 1966–1990* (Cambridge, MA: MIT Press, 1991), 220. Robert Morris, "Anti Form," *Artforum* 6, no. 8 (1968), 35. Bruce Nauman, quoted in Joan Simon, "Breaking the Silence: An Interview with Bruce Nauman," *Art in America* 76, no. 9 (1988), 147. Michelangelo Pistoletto, "The Minus Man: The Unbearable Side," in *A Minus Artist* (Florence: Hopeful Monster, 1988), 127. Robert Rauschenberg, interview by Dorothy Seckler, December 21, 1965, Archives of American Art, quoted in *Robert Rauschenberg On and Off the Wall*, exh. cat. (Nice: Musée d'Art Moderne et d'Art Contemporain, 2006), 54. Edward Ruscha, "Interview with Edward Ruscha, June 1985," in Bernard Brunon, *Edward Ruscha* (Lyon: Musée Saint Pierre Art Contemporain, 1985), 89. Cy Twombly, "Cy Twombly (2000)," in David Sylvester, *Interviews with American Artists* (New Haven, CT: Yale University Press, 2000), 173. Andy Warhol, quoted in John Perreault, "Andy Warhol," *Vogue* 155, no. 3 (1970), quoted in Alan R. Pratt, ed., *The Critical Response to Andy Warhol* (Westport, CT: Greenwood Press, 1997), 65.

M.C.

Untitled, 2009

TAXIDERMIED DOG

LIFE-SIZE

The 53rd Venice Biennale, The Danish and Nordic Pavilions, an exhibition curated by Elmgreen / Dragset

As to why I use stand-ins when I am invited to speak in public, the answer is simple: I always find other people more interesting than myself. Am I talking to you now, or is it someone else? The answer is inside you, and it's wrong.

M.C.

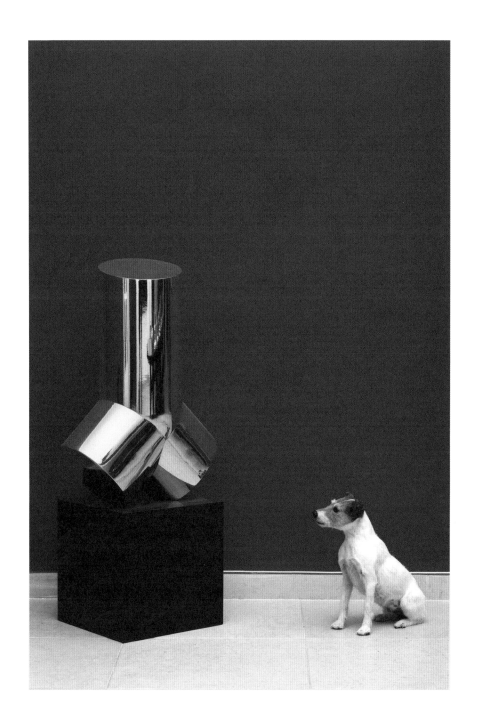

Published on the occasion of the exhibition "Maurizio Cattelan"
Organized by The Menil Collection, Houston, February 12–August 15, 2010

Curated by Franklin Sirmans

This exhibition is generously supported by Marion Barthelme and Jeff Fort; Frances Dittmer;
Barbara and Michael Gamson; William J. Hill; Jackson and Company; Sotheby's;
The Stardust Fund; Nina and Michael Zilkha; the Istituto Italiano di Cultura, Los Angeles,
directed by Francesca Valente; and the City of Houston.

PUBLISHER Laureen Schipsi
PUBLICATIONS ASSISTANTS Jennifer Hall and Sarah Robinson
PUBLICATIONS INTERN Sean Nesselrode
DESIGN Purtill Family Business
PRINTER Shapco Printing, Inc., Minneapolis

Published by
Menil Foundation, Inc.
1511 Branard Street
Houston, Texas 77006

Distributed by Yale University Press
P.O. Box 209040, 302 Temple Street
New Haven, Connecticut 06520-9040
www.yalebooks.com

Hardcover ISBN: 978-0-300-14688-2
Library of Congress Control Number: 2009940533

Printed in the USA